NOV 15

Brooklyn: A Personal Memoir

WITH THE LOST PHOTOGRAPHS OF DAVID ATTIE

Brooklyn:
A PERSONAL MEMOIR
Truman Capote

WITH THE LOST PHOTOGRAPHS OF
David Attie

INTRODUCTION
George Plimpton

AFTERWORD
Eli Attie

THE LITTLE BOOKROOM
NEW YORK

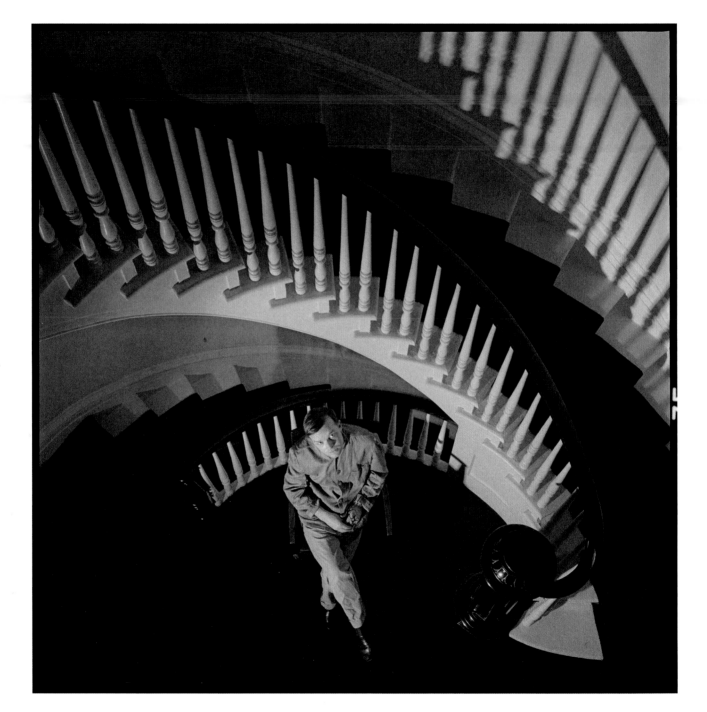

Introduction

GEORGE PLIMPTON

Back in the fifties, John Knowles, the author of *A Separate Peace*, who held an editorial position with *Holiday* magazine, suggested Truman Capote as a possible contributor to its pages. Knowles, who didn't know Capote at the time, volunteered to arrange a meeting, which eventually took place between the two in the Oak Room of the Plaza Hotel. As Knowles remembered it: "He came in from Brooklyn . . . this incredible little person in a black velvet suit with blond bangs swinging, looking this way and that to see where I was. He took to me instantly. He decided to annex me, to add me to his friends. Once Truman made up his mind to do that, that was it. That night he was going on to read from his work in progress, which was *Breakfast at Tiffany's*. I said, 'Mr. Capote, shouldn't we be leaving? It's almost time for your reading.' He said, 'Let them wait, the hell with them!' He had another drink, of course. We got to the Ninety-Second Street Y late, and he read in that extraordinary voice of his, which was like nothing on earth."

The eventual result of that meeting in the Plaza—to the delight of the *Holiday* editors—was the work published soon after in its pages and which is included here: a warm portrait of Brooklyn Heights, where Capote was living at the time, titled "A House on the Heights."

Its address was on Willow Street, close by the Esplanade with its striking view of lower Manhattan and the Bay. Oddly, Truman devotes only a paragraph or so to his actual living quarters, perhaps because as a tenant there (his landlord was Oliver Smith, the famous stage designer) he lived below street level in two basement rooms. When friends came to call, he often took them on a tour of the entire house (when Smith was not

at home) and said it was his house, all his, and that he had restored and decorated every room.

The feature of the house, which must have been a rich merchant's at one time, or a sea captain's, was a great spiral staircase that soared up to a skylight with, off its landings, according to Truman, twenty-eight rooms. One of them (which Truman does not mention) contained Oliver Smith's mother's favorite furniture—old beaded lampshades, rocking chairs—indeed a room whose décor must have given Truman pause to explain to his friends on his tours.

Outside, beyond a veranda with its arbor of wisteria, was a garden where one sat in the summer and had little sandwiches and wine. Mrs. Charles Francis Adams, Bee Dabney then, a beautiful girl with slanted eyes, one of the models by Truman's admission for the character of Holly Golightly of *Breakfast at Tiffany's*, remembers being picked up in Manhattan to drive out to the Heights by car, an open convertible, sailing along the East River Drive with Truman at the wheel, a long scarf around his neck. He could barely see over the dashboard . . . "rather like Mr. Toad from *Wind in the Willows*."

She recalls the "childedness" of his little below-decks apartment, yellow-tiled floors, big cushions, and that Truman served up canned soup when it was chilly along with "delicious stories about people we both knew."

It was from these digs that Truman set out to do his research on the neighborhood. What an eye! Truman always boasted that he had 95 percent total recall of conversations he was privy to (though sometimes he forgot and said it was 93 percent) but certainly his visual perceptions were unerring—this coupled with a love of history, gossip, character, and a skill at putting all this to words that in his memoir brings Brooklyn Heights to life as vividly as any landscape Truman ever undertook to survey.

One of its main characters is George Knapp, a dealer in antiques, knickknacks, curiosities. It was very likely that from him Truman purchased the ceramic cats and leopards

that sat about on shelves in the Brooklyn apartment, and perhaps the first of, or at least added to, his considerable collection of paperweights. On occasion, he gave away one of his paperweights, invariably overstating its provenance: "this once belonged, you should know, to a czarina of Russia!"

The ending of this memoir has struck some, including John Knowles at the time, as quite unsettling. One wonders if the *Holiday* editors would have preferred a more "upbeat" ending—surely for a magazine whose editorial policy was to entice readers to wondrous and safe locales, certainly not those inhabited by such as the "Cobras" of Brooklyn Heights.

How peculiar but perhaps prescient it is to recall that among George Knapp's "treasures" in his storerooms were the skeletons of snakes. Truman added such sinister collectibles (he claimed he had been bitten by a snake as a child) to his lovely paperweights and ceramic cats. When he moved from Brooklyn to Manhattan, to his apartment high in the UN Plaza, the snakes became what one first noticed: a stuffed, coiled rattlesnake, a tree branch with a snake intertwined that hovered over a chair . . . a change from the basement rooms in Brooklyn that a friend of his described as "one of the quietest places I have been in my life" to a venue that overlooked the lights of downtown Manhattan, the parlors of the rich and fashionable, Studio 54, places that turned out to be far more dangerous than the alleys in which lurked the Cobras of the Heights. The UN Plaza was not the kind of Willow Street sanctuary to which he could run as he did from the Cobras.

Enough of this. Better to recall what James Dickey spoke of Truman Capote at a commemorative tribute at the annual meeting of the American Academy and Institute of Arts and Letters—the essence of Truman's talent described in as compelling a way as one can hope for: "His writing came, first, from a great and real interest in many things and people, and then from a frozen detachment that he practiced as one might practice the piano, or a foot position in ballet. Cultivated in this manner, his powers of absorption and his memory were already remarkable, particularly in the recreation of small details. He

possessed to an unusual degree this ability to encapsulate himself with his subject, whatever or whoever it might be, so that nothing else existed except him and the other: and then he himself would begin to fade away and words would appear in his place: words concerning the subject, as though it were dictating itself."

Dickey went on to say: "The sure-handed crystal-making detachment, the integrity of concentration, the craft of the artist by means of which the intently human thing is caught, Truman Capote had, and not just at certain times but all times."

How true this is in what follows:

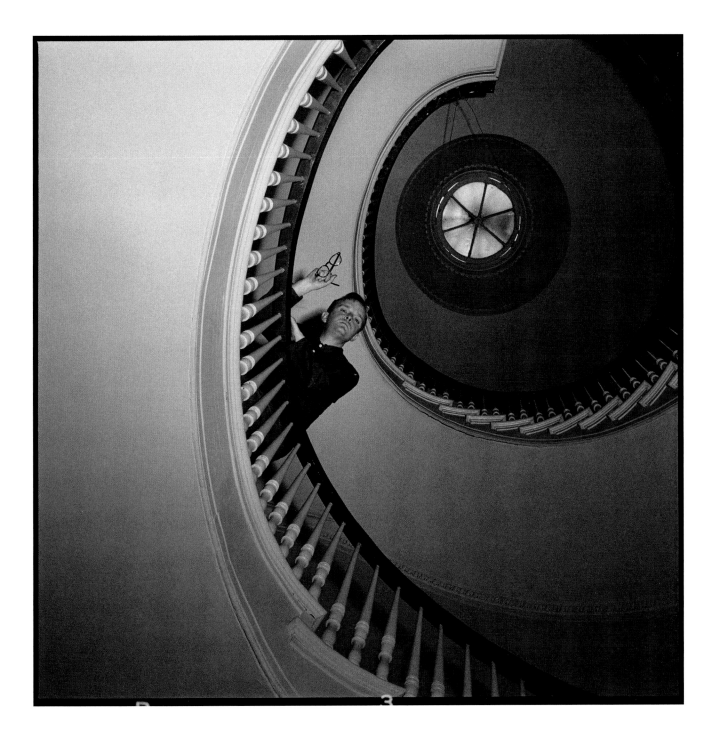

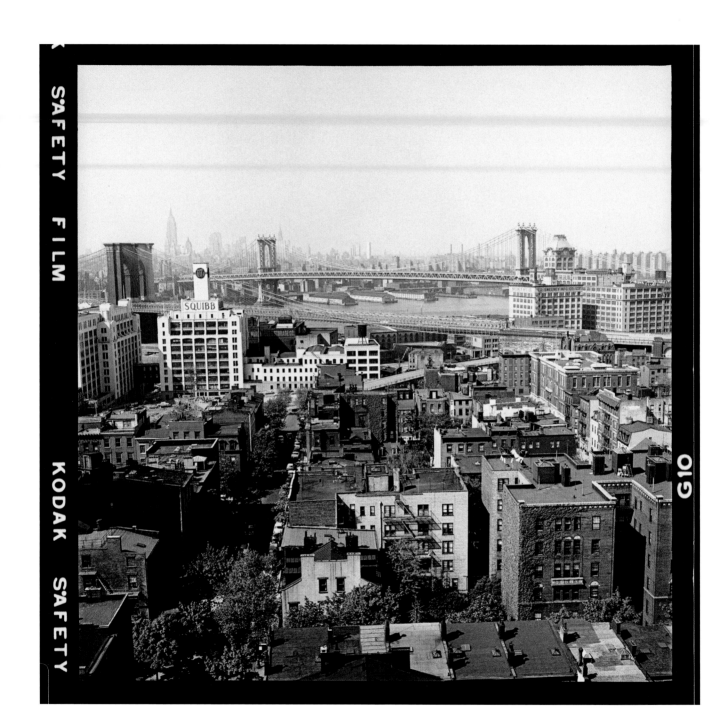

SQUIBB

Brooklyn: A Personal Memoir

I live in Brooklyn. By choice.

Those ignorant of its allures are entitled to wonder why. For, taken as a whole, it *is* an uninviting community. A veritable veldt of tawdriness where even the *noms des quartiers* aggravate: Flatbush and Flushing Avenue, Bushwick, Brownsville, Red Hook. Yet, in the greenless grime-gray, oases do occur, splendid contradictions, hearty echoes of healthier days. Of these seeming mirages, the purest example is the neighborhood in which I am situated, an area known as Brooklyn Heights. Heights, because it stands atop a cliff that secures a sea-gull's view of the Manhattan and Brooklyn bridges, of lower Manhattan's tall dazzle and the ship-lane waters, breeding river to bay to ocean, that encircle and seethe past posturing Miss Liberty.

I'm not much acquainted with the proper history of the Heights. However, I *believe* (but please don't trust me) that the oldest house, the oldest still extant and functioning, belongs to our back-yard neighbors, Mr. and Mrs. Philip Broughton. A silvery gray, shingle-wood Colonial shaded by trees robustly leafed, it was built in 1790, the home of a sea captain. Period prints, dated 1830, depict the Heights area as a cozy port bustling with billowed sails; and, indeed, many of the section's finer houses, particularly those of Federal design, were first intended to shelter the families of shipmasters. Cheerfully austere, as elegant and other-era as formal calling cards, these houses bespeak an age of able servants and solid fireside ease; of horses in musical harness (old rose-brick carriage houses abound hereabouts; all now, naturally, transformed into pleasant, if rather doll-pretty, dwellings); invoke specters of bearded seafaring fathers and bonneted stay-at-home wives: devoted parents to great broods of future bankers and fashionable brides. For a century or so that is how it must have been: a time of tree-shrouded streets, lanes

limp with willow, August gardens brimming with bumblebees and herbaceous scent, of ship horns on the river, sails in the wind, and a country-green meadow sloping down to the harbor, a cow-grazing, butterflied meadow where children sprawled away breezy summer afternoons, where the slap of sleds resounded on December snows.

Is that how it was? Conceivably I take too Valentine a view. However it be, my Valentine assumes the stricter aspect of a steel engraving as we mosey, hand in hand, with Henry Ward Beecher, whose church once dominated the spiritual life of the Heights, through the latter half of the last century. The great Bridge, opened in 1883, now balanced above the river; and the port, each year expanding, becoming a more raucous, big-business matter, chased the children out of the meadow, withered it, entirely whacked it away to make room for black palace-huge warehouses tickly with imported tarantulas and reeking of rotten bananas.

By 1910, the neighborhood, which comprises sly alleys and tucked-away courts and streets that sometimes run straight but also dwindle and bend, had undergone fiercer vicissitudes. Descendants of the Reverend Beecher's stiff-collared flock had begun removing themselves to other pastures; and immigrant tribes, who had first ringed the vicinity, at once infiltrated en masse. Whereupon a majority of what remained of genteel old stock, the sediment in the bottom of the bottle, poured forth from their homes, leaving them to be demolished or converted into eyesore-seedy rooming establishments.

So that, in 1925, Edmund Wilson, allowing a paragraph to what he considered the dead and dying Heights, disgustedly reported: "The pleasant red and pink brick houses still worthily represent the generation of Henry Ward Beecher; but an eternal Sunday is on them now; they seem sunk in a final silence. In the streets one may catch a glimpse of a solitary well-dressed old gentleman moving slowly a long way off; but in general the respectable have disappeared and only the vulgar survive. The empty quiet is broken by the shouts of shrill Italian children and by incessant mechanical pianos in dingy

apartment houses, accompanied by human voices that seem almost as mechanical as they. At night, along unlighted streets, one gives a wide berth to drunkards that sprawl out across the pavement from the shadow of darkened doors; and I have known a dead horse to be left in the road—two blocks from the principal post office and not much more from Borough Hall—with no effort made to remove it, for nearly three weeks."

Gothic as this glimpse is, the neighborhood nevertheless continued to possess, cheap rents aside, some certain appeal brigades of the gifted—artists, writers—began to discover. Among those riding in on the initial wave was Hart Crane, whose poet's eye, focusing on his window view, produced *The Bridge*. Later, soon after the success of *Look Homeward, Angel*, Thomas Wolfe, noted prowler of the Brooklyn night, took quarters: an apartment, equipped with the most publicized icebox in literature's archives, which he maintained until his "overgrowed carcass" was carried home to the hills of Carolina. At one time, a stretch of years in the early forties, a single, heaven knows singular, house on Middagh Street boasted a roll call of residents that read: W. H. Auden, Richard Wright, Carson McCullers, Paul and Jane Bowles, the British composer Benjamin Britten, impresario and stage designer Oliver Smith, an authoress of murder entertainments, Miss Gypsy Rose Lee, and a Chimpanzee accompanied by Trainer. Each of the tenants in this ivory-tower boarding house contributed to its upkeep, lights, heat, the wages of a general cook (a former Cotton Club chorine), and all were present at the invitation of the owner, that very original editor, writer, *fantaisiste*, a gentleman with a guillotine tongue, yet benevolent and butter-hearted, the late, the justly lamented George Davis.

Now George is gone; and his house too: the necessities of some absurd civic project caused it to be torn down during the war. Indeed, the war years saw the neighborhood slide to its nadir. Many of the more substantial old houses were requisitioned by the military, as lodgings, as jukebox canteens, and their rural-reared, piney-woods personnel

treated them quite as Sherman did those Dixie mansions. Not that it mattered; not that anyone gave a damn. No one did; until, soon after the war, the Heights commenced attracting a bright new clientele, brave pioneers bringing brooms and buckets of paint: urban, ambitious young couples, by and large mid-rung in their Doctor-Lawyer-Wall Street-Whatever careers, eager to restore to the Heights its shattered qualities of circumspect, comfortable charm.

For them, the section had much to offer: roomy big houses ready to be reconverted into private homes suitable for families of old-fashioned size; and such families are what these young people either had made or were making at stepladder rates. A good place to raise children, too, this neighborhood where the traffic is cautious, and the air has clarity, a seaside tartness; where there are gardens for games, quiet stoops for amusing; and where, above all, there is the Esplanade to roller-skate upon. (Forbidden: still the brats do it.) While far from being a butterflied meadow, the Esplanade, a wide terrace-like walk overlooking the harbor, does its contemporary best to approximate that playing pasture of long-gone girls and their brothers.

So, for a decade and longer, the experiment of reviving the Heights has proceeded: to the point where one is tempted to term it a *fait accompli*. Window boxes bloom with geraniums; according to the season, green foliated light falls through the trees or gathered autumn leaves burn at the corner; flower-loaded wagons wheel by while the flower seller sings his wares; in the dawn one occasionally hears a cock crow, for there is a lady with a garden who keeps hens and a rooster. On winter nights, when the wind brings the farewell callings of boats outward bound and carries across rooftops the chimney smoke of evening fires, there is a sense, evanescent but authentic as the firelight's flicker, of time come circle, of ago's sweeter glimmerings recaptured.

Though I'd long been acquainted with the neighborhood, having now and then visited there, my closer association began two years ago when a friend bought a house

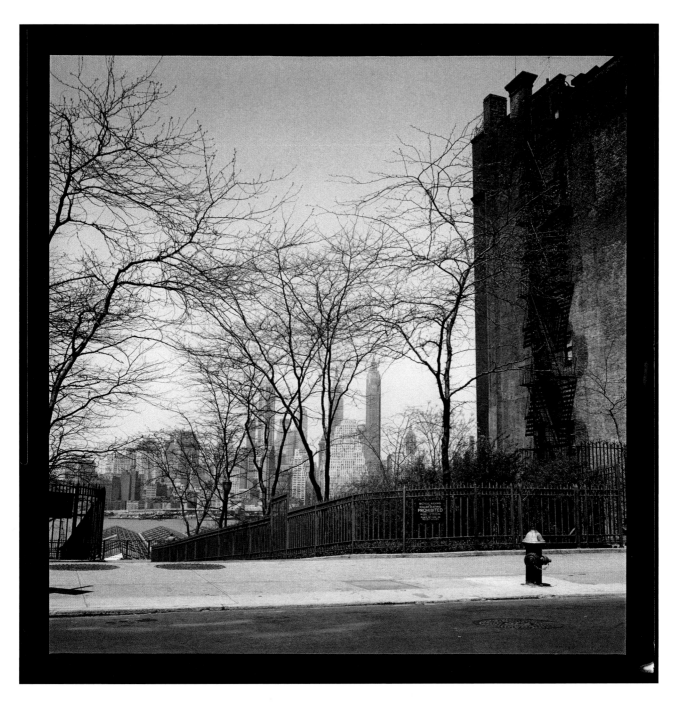

PROHIBITED

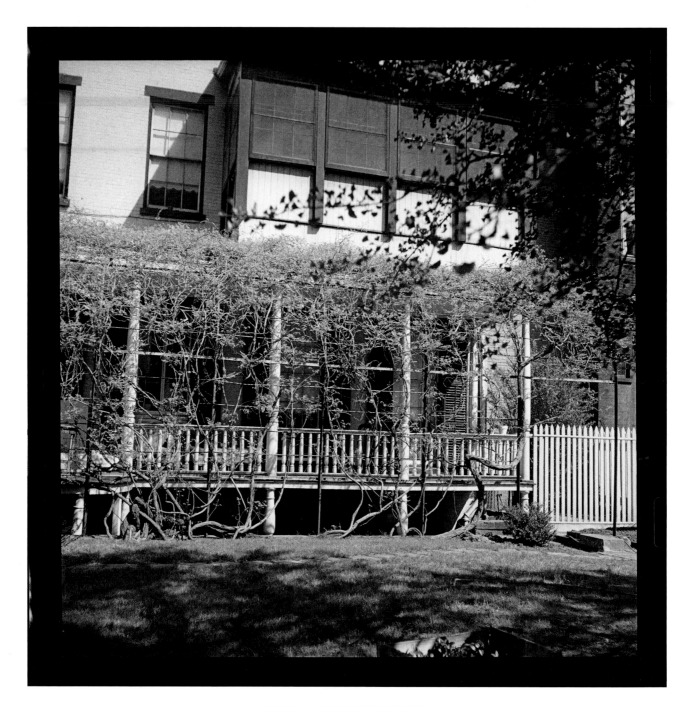

REAR, 70 WILLOW STREET

on Willow Street. One mild May evening he asked me over to inspect it. I was most impressed; exceedingly envious. There were twenty-eight rooms, high-ceilinged, well proportioned, and twenty-eight workable, marble-manteled fireplaces. There was a beautiful staircase floating upward in white, swan-simple curves to a skylight of sunny amber-gold glass. The floors were fine, the real thing, hard lustrous timber; and the walls! In 1820, when the house was built, men knew how to make walls—thick as a buffalo, immune to the mightiest cold, the meanest heat.

French doors led to a spacious rear porch reminiscent of Louisiana. A porch canopied, completely submerged, as though under a lake of leaves, by an ancient but admirably vigorous vine weighty with grapelike bunches of wisteria. Beyond, a garden: a tulip tree, a blossoming pear, a perched black-and-red bird bending a feathery branch of forsythia.

In the twilight, we talked, my friend and I. We sat on the porch consulting Martinis—I urged him to have one more, another. It got to be quite late, he began to see my point: yes, twenty-eight rooms *were* rather a lot; and yes, it seemed only *fair* that I should have some of them.

That is how I came to live in the yellow brick house on Willow Street.

Often a week passes without my "going to town," or "crossing the bridge," as neighbors call a trip to Manhattan. Mystified friends, suspecting provincial stagnation, inquire: "But what do you *do* over there?" Let me tell you, life can be pretty exciting around here. Remember Colonel Rudolf Abel, the Russian secret agent, the biggest spy ever caught in America, head of the whole damned apparatus? Know where they nabbed him? Right here! smack on Fulton Street! Trapped him in a building between David Semple's fine-foods store and Frank Gambuzza's television repair shop. Frank, grinning as though he'd done the job himself, had his picture in *Life*; so did the waitress at the Music Box Bar, the colonel's favorite watering hole. A peevish few of us couldn't

fathom why our pictures weren't in *Life* too. Frank, the Music Box Bar girl, they weren't the only people who knew the colonel. Such a gentleman-like gentleman: one would never have *supposed*. . . .

I confess, we don't catch spies every day. But most days are supplied with stimulants: in the harbor some exotic freighter to investigate; a bird of strange plumage resting among the wisteria; or, and how exhilarating an occurrence it is, a newly arrived shipment at Knapp's. Knapp's is a set of shops, really a series of storerooms resembling caverns, clustered together on Fulton near Pineapple Street. The proprietor—that is too modest a designation for so commanding a figure—the czar, the Aga Khan of these paradisal emporiums is Mr. George Knapp, known to his friends as Father.

Father is a world traveler. Cards arrive: he is in Seville, now Copenhagen, now Milan, next week Manchester, everywhere and all the while on a gaudy spending spree. Buying: blue crockery from a Danish castle. Pink apothecary jars from an old London pharmacy. English brass, Barcelona lamps, Battersea boxes, French paperweights, Italian witch balls, Greek icons, Venetian blackamoors, Spanish saints, Korean cabinets; and junk, glorious junk, a jumble of ragged dolls, broken buttons, a stuffed kangaroo, an aviary of owls under a great glass bell, the playing pieces of obsolete games, the paper moneys of defunct governments, an ivory umbrella cane *sans* umbrella, crested chamber pots and mustache mugs and irreparable clocks, cracked violins, a sundial that weighs seven hundred pounds, skulls, snake vertebrae, elephants' hoofs, sleigh bells and Eskimo carvings and mounted swordfish, medieval milkmaid stools, rusted firearms and flaking waltz-age mirrors.

Then Father comes home to Brooklyn, his treasures trailing after him. Uncrated, added to the already perilous clutter, the blackamoors prance in the marvelous gloom, the swordfish glide through the store's Atlantic-depth dusk. Eventually they will go: fancier *antiquaires*, and anonymous mere beauty lovers, will come, cart them away. Meanwhile,

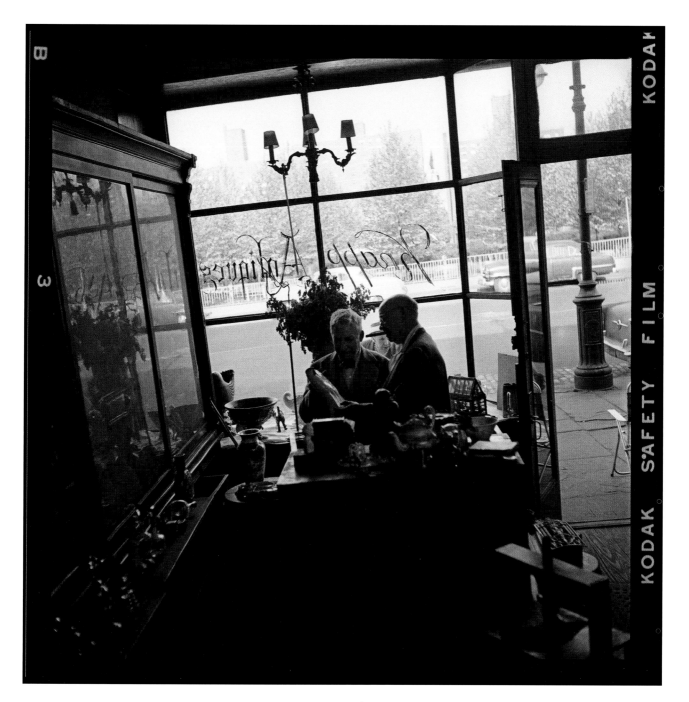

KNAPP'S

poke around. You're certain to find a plum; and it may be a peach. That paperweight—the one imprisoning a Baccarat dragonfly. If you want it, take it now: tomorrow, assuredly the day after, will see it on Fifty-Seventh Street at quintuple the tariff.

Father has a partner, his wife Florence. She is from Panama, is handsome, fresh-colored and tall, trim enough to look well in the trousers she affects, a woman of proud posture and, vis-à-vis customers, of nearly eccentric curtness, take-it-or-go disdain—but then, poor soul, she is under the discipline of not being herself permitted to sell, even quote a price. Only Father, with his Macaulayan memory, his dazzling ability to immediately lay hold of any item in the dizzying maze, is so allowed. Brooklyn-born, waterfront-bred, always hatted and usually wearing a wet cold cigar, a stout, short, round powerhouse with one arm, with a strutting walk, a rough-guy voice, shy nervous sensitive eyes that blink when irritation makes him stutter, Father is nevertheless an aesthete. A tough aesthete who takes no guff, will not quibble over his evaluations, just declares: "Put it down!" and, "Get it Manhattan half the money, I give it yuh free." They are an excellent couple, the Knapps. I explore their museum several times a week, and toward October, when a Franklin stove in the shape of a witch hut warms the air and Florence serves cider accompanied by a damp delicious date-nut bread she bakes in discarded coffee-cans, never miss a day. Occasionally, on these festive afternoons, Father will gaze about him, blink-blink his eyes with vague disbelief, then, as though his romantic accumulations were closing round him in a manner menacing, observe: "I got to be crazy. Putting my heart in a fruitcake business like this. And the *investment*. The money alone! Honest, in your honest opinion, wouldn't you say I'm crazy?"

Certainly not. If, however, Mrs. Cornelius Oosthuizen were to beg the question—

It seems improbable that someone of Mrs. Oosthuizen's elevation should have condescended to distinguish me with her acquaintance. I owe it all to a pound of dog meat. What happened was: the butcher's boy delivered a purchase of mine which, by error,

included hamburger meant to go to Mrs. O. Recognizing her name on the order slip, and having often remarked her house, a garnet-colored château in mood remindful of the old Schwab mansion on Manhattan's Riverside Drive, I thought of taking round the package myself, not dreaming to meet the fine lady, but, at most, ambitious for a moment's glance into her fortunate preserve. Fortunate, for it boasted, so I'd had confided to me, a butler and staff of six. Not that this is the Height's sole *maision de luxe*: we are blessed with several exponents of limousine life—but unarguably, Mrs. O. is *la regina di tutti*.

Approaching her property, I noticed a person in Persian lamb very vexedly punching the bell, pounding a brass knocker. "God damn you, Mabel," she said to the door; then turned, glared at me as I climbed the steps—a tall intimidating replica of frail unforbidding Miss Marianne Moore (who, it may be recalled, is a Brooklyn lady too). Pale lashless eyes, razor lips, hair a silver fuzz. "Ah, *you*. I know you," she accused me, as behind her the door was opened by an Irish crone wearing an ankle-length apron. "So. I suppose you've come to sign the petition? Very good of you, I'm sure." Mumbling an explanation, muttering servile civilities, I conveyed the butcher's parcel from my hands to hers; she, as though I'd tossed her a rather rotten fish, dangled it gingerly until the maid remarked: "Ma'am, 'tis Miss Mary's meat the good lad's brought."

"Indeed. Then don't stand there, Mabel. Take it." And, regarding me with a lessening astonishment that I could not, in her behalf, reciprocate: "Wipe your boots, come in. We will discuss the petition. Mabel, send Murphy with some Bristol and biscuit. . . . Oh? At the dentist's! When I *asked* him *not* to tamper with that tooth. What hellish nonsense," she swore, as we passed into a hatrack-vestibule. "Why didn't he go to the hypnotist, as I told him? Mary! Mary! Mary," she said when now appeared a friendly nice dog of cruel pedigree: a spaniel *cum* chow attached to the legs of a dachshund, "I believe Mabel has your lunch. Mabel, take Miss Mary to the kitchen. And we will have our biscuits in the Red Room."

The room, in which red could be discerned only in a bowl of porcelain roses and a basket of marzipan strawberries, contained velvet-swagged windows that commanded a pulse-quickening prospect: sky, skyline, far away a wooded slice of Staten Island. In other respects, the room, a heavy confection, cumbersome, humorless, a hunk of Beidermeier pastry, did not recommend itself. "It was my grandmother's bedroom; my father preferred it as a parlor. Cornelius, Mr. Oosthuizen, died here. Very suddenly: while listening at the radio to the Roosevelt person. An attack. Brought on by anger and cigars. I'm sure you won't ask permission to smoke. Sit down. . . . Not there. There, by the window. Now here, it *should* be here, somewhere, in this drawer? Could it be upstairs? Damn Murphy, horrid man always meddling with my—no, I have it: the petition."

The document stated, and objected to, the plans of a certain minor religious sect that had acquired a half-block of houses on the Heights which they planned to flatten and replace with a dormitory building for the benefit of their Believers. Appended to it were some dozen protesting signatures; the Misses Seeley had signed, and Mr. Arthur Veere Vinson, Mrs. K. Mackaye Brownlowe—descendants of the children in the meadow, the old-guard survivors of *their* neighborhood's evilest hours, those happy few who regularly attended Mrs. O.'s black-tie-sit-downs. She wasted no eloquence on the considerable merit of their complaint; simply, "Sign it," she ordered, a Lady Catherine de Bourgh instructing a Mr. Collins.

Sherry came; and with it an assembly of cats. Scarred battlers with leprous fur and punch-drunk eyes. Mrs. O., motioning toward the least respectable of these, a tiger-striped marauder, told me: "This is the one you may take home. He's been with us a month, we've put him in splendid condition, I'm sure you'll be devoted. Dogs? What *sort* of dogs have you? Well, I don't approve the pure breeds. Anyone will give *them* a home. I took Miss Mary off the street. And Lovely Louise, Mouse and Sweet William— my dogs, all my cats, too, came off the streets. Look below, there in the garden. Under

the heaven tree. Those markings: graves are what you see, some as old as my childhood. The seashells are goldfish. The yellow coral, canaries. That white stone is a rabbit; that cross of pebbles: my favorite, the first Mary—angel girl, went bathing in the river and caught a fatal chill. I used to tease Cornelius, Mr. Oosthuizen, told him, ha-ha, told him I planned to put him there with the rest of my darlings. Ha-ha, he wasn't amused, not at all. So, I mean to say, your having dogs doesn't signify: Billy here has such spirit, *he* can hold his own. No, I insist you have him. For I can't keep him much longer, he's a disturbing influence; and if I let him loose, he'll run back to his bad old life in the St. George alley. I wouldn't want *that* on my conscience if I were you."

Her persuasions failed; in consequence our parting was cool. Yet at Christmas she sent me a card, a Cartier engraving of the heaven tree protecting the bones in its sad care. And once, encountering her at the bakery, where we both were buying brownies, we discussed the impudent disregard her petition had received: alas, the wreckers had wrecked, the brethren were building. On the same occasion, she shame-on-you informed me that Billy the cat, released from her patronage, had indeed returned to the sinful ways of the St. George alley.

The St. George alley, adjoining a small cinema, is a shadowy shelter for vagrants: wino derelicts wandered over the bridge from Chinatown and the Bowery share it with other orphaned, gone-wild creatures: cats, as many as minnows in a stream, who gather in their greatest numbers toward nightfall; for then, as darkness happens, strange-eyed women, not unlike those black-clothed fanatics who haunt the cat arenas in Rome, go stealing through the alley with caressing hisses and sacks of crumbled salmon. (Which isn't to suggest that Mrs. O. is one who indulges in this somehow unhealthy hobby: regarding animals, her actions, while perhaps a bit overboard, are kindly meant, and not untypical of the Heights, where a high percentage of the pet population has been adopted off the streets. Astonishing, really, the amount of lost strays who roam their

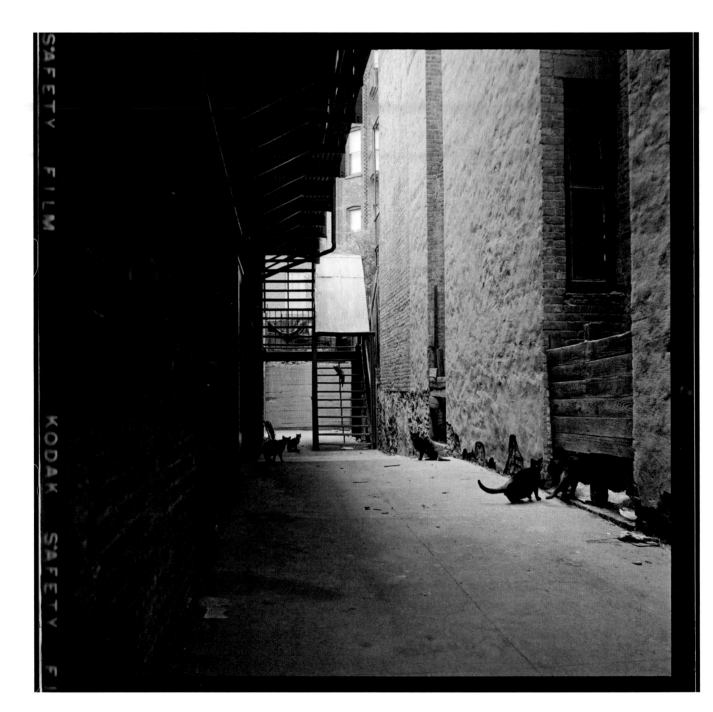

CATS

way into the neighborhood, as though instinct informed them they'd find someone here who couldn't abide being followed through the rain, but would, instead, lead them home, boil milk, and call Dr. Wasserman, Bernie, our smart-as-they-come young vet whose immaculate hospital resounds with the music of Bach concertos and the barkings of mending beasts.)

Just now, in connection with these notes, I was hunting through a hieroglyphic shambles I call my journal. Odd, indeed the oddest, jottings—a majority of which conceal from me their meanings. God knows what "Thunder on Cobra Street" refers to. Or "A diarrhea of platitudes in seventeen tongues." Unless it is intended to describe a most tiresome local person, a linguist terribly talkative in many languages though articulate in none. However, "Took T&G to G&T" does make sense.

The first initials represent two friends, the latter a restaurant not far away. You must have heard of it, Gage & Tollner. Like Kolb's and Antoine's in New Orleans, Gage & Tollner is a last-century enterprise that has kept in large degree its founding character. The shaky dance of its gaslight chandeliers is not a period-piece hoax; nor do the good plain marble-topped tables, the magnificent array of gold-edged mirrors, seem sentimental affectations—rather, it is a testament to the seriousness of the proprietors, who have obliged us by letting the place stay much as it was that opening day in 1874. One mightn't suppose it, for in the atmosphere there is none of the briny falderal familiar to such aquariums, but the specialty is sea food. The best. Chowders the doughtiest down-Easter must approve. Lobsters that would appease Nero. Myself, I am a soft-shelled-crab *aficionado*: a plate of sautéed crabs, a halved lemon, a glass of chilled Chablis: most satisfactory. The waiters, too, dignified but swift-to-smile Negroes who take pride in their work, contribute to the goodness of Gage & Tollner; on the sleeves of their very laundered jackets they sport military-style chevrons awarded according to the number of years each has served; and, *were* this the Army, some would be generals.

Nearby, there is another restaurant, a fraction less distinguished, but of similar vintage and virtually the same menu: Joe's—Joe being, by the way, an attractive young lady. On the far fringes of the Heights, just before Brooklyn becomes Brooklyn again, there is a street of Gypsies with Gypsy cafés (have your future foretold and be tattooed while sipping tankards of Moorish tea); there is also an Arab-Armenian quarter sprinkled with spice-saturated restaurants where one can buy, hot from the oven, a crusty sort of pancake frosted with sesame seed—once in a while I carry mine down to the waterfront, intending to share with the gulls; but, gobbling as I go, none is ever left. On a summer's evening a stroll across the bridge, with cool winds singing through the steel shrouds, with stars moving about above and ships below, can be intoxicating, particularly if you are headed toward the roasting-pork, sweet-and-sour aromas of Chinatown.

Another journal notation reads, "At last a face in the ghost hotel!" Which means: after months of observation, in all climates at all hours, I'd sighted someone in a window of a haunted-seeming riverfront building that stands on Water Street at the foot of the Heights. A lonely hotel I often make the destination of my walks: because I think it romantic, in aggravated moments imagine retiring there, for it is as secluded as Mt. Athos, remoter than the Krak Chevalier in the mountains of wildest Syria. Daytimes the location, a dead-end Chiricoesque piazza facing the river, is little disturbed; at night, not at all: not a sound, except foghorns and a distant traffic whisper from the bridge which bulks above. Peace, and the shivering glow of gliding-by tugs and ferries.

The hotel is three-storied. Sunstruck scraps of reflected river-shine, and broken, jigsaw images of the bridge waver across the windows; but beyond the glass nothing stirs: the rooms, despite contradictory evidence, milk bottles on sills, a hat on a hook, unmade beds and burning bulbs, appear unoccupied: never a soul to be seen. Like the sailors of the *Marie Celeste*, the guests, hearing a knock, must have opened their doors to

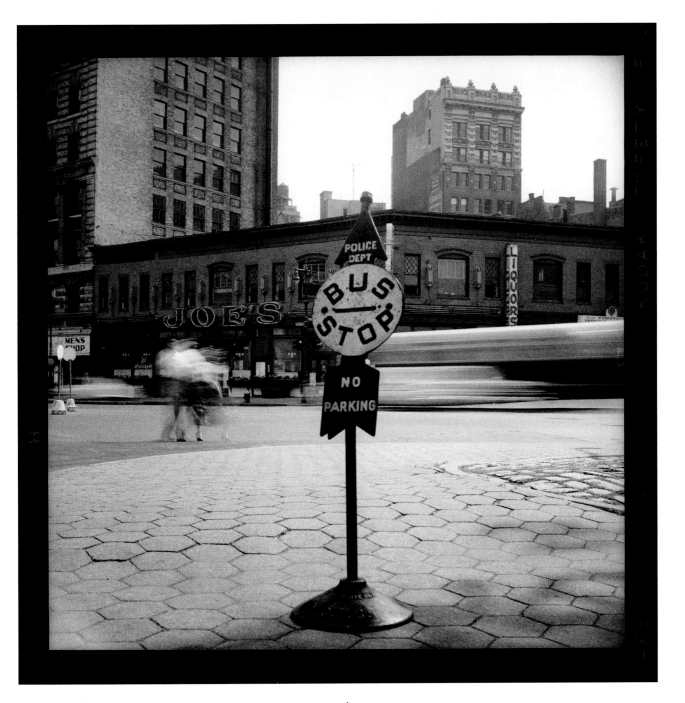

JOE'S

a stranger who swallowed them whole. Could it be, perhaps it *was*, the stranger himself that I saw?—"At last a face in the ghost hotel!" I glimpsed him just the once, one April afternoon one cloudless blue day; and he, a balding man in an undershirt, hurled up a window, flexed hairy arms, yawned hugely, hugely inhaled the river breeze—was gone. No, on careful second thought, I will never set foot in that hotel. For I should either be devoured or have my mystery dispelled. As children we are sensitive to mystery: locked boxes, whisperings behind closed doors, the what-thing that lurks yonder in the trees, waits in every stretch between street lamps; but as we grow older all is too explainable, the capacity to invent pleasurable alarm recedes: too bad, a pity—throughout our lives we ought to believe in ghost hotels.

Close by the hotel begins a road that leads along the river. Silent miles of warehouses with shuttered wooden windows, docks resting on the water like sea spiders. From May through September, *la saison pour la plage*, these docks are diving boards for husky raga-muffins—while perfumed apes, potentates of the waterfront but once dock-divers them-selves, cruise by steering two-toned (banana-tomato) car concoctions. Crane-carried tractors and cotton bales and unhappy cattle sway above the holds of ships bound for Bahia, for Bremen, for ports spelling their names in Oriental calligraphy. Provided one has made waterfront friends, it is sometimes possible to board the freighters, carouse and sun yourself: you may even be asked to lunch—and I, for one, am always quick to accept, embarrassingly so if the hosts are Scandinavian: they always set a superior table from larders brimming with smoked "taste thrills" and iced aquavit. Avoid the Greek ships, however: very poor cuisine, no liquor served except *ouzo*, a sickly licorice syrup; and, at least in the opinion of this panhandler, the grub on French freighters by no means meets the standards one might reasonably expect.

The tugboat people are usually good for a cup of coffee, and in wintry weather, when the river is tossing surf, what joy to take refuge in a stove-heated tug cabin and

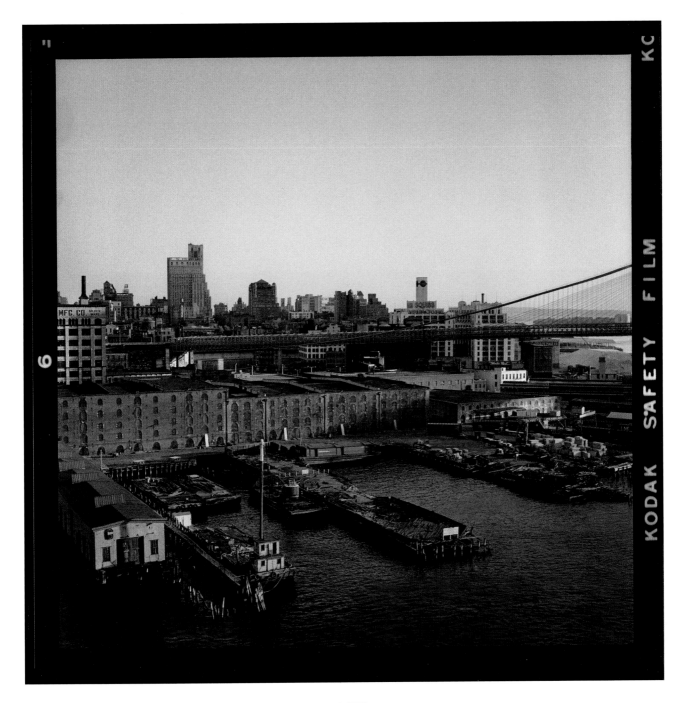

DOCKS

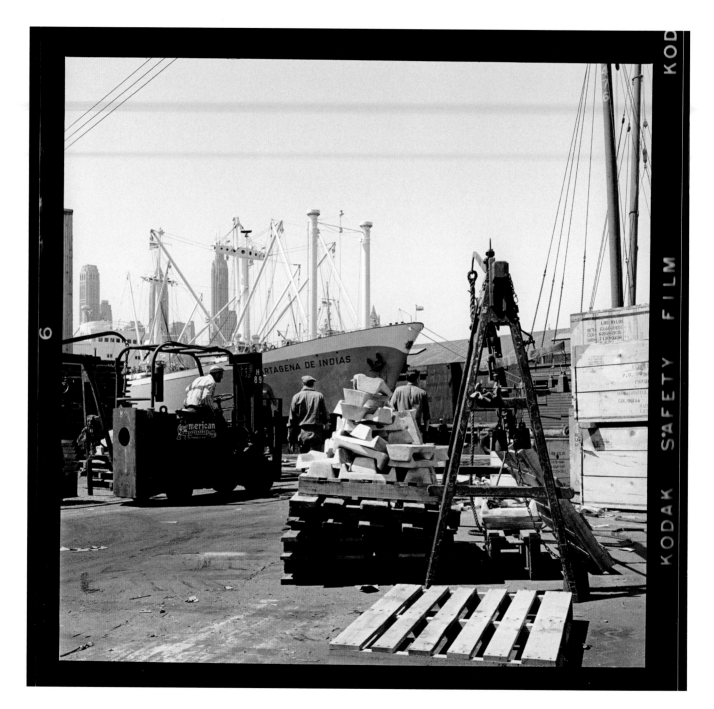

CARTAGENA DE INDIAS

thaw out with a mug of the blackest Java. Now and again along the route minuscule beaches occur, and once, it was around sunset on a quiet Sunday, I saw on one of them something that made me look twice, and twice more: still it seemed a vision. Every kind of sailor is common enough here, even saronged East Indians, even the giant Senegalese, their onyx arms afire with blue, with yellow tattooed flowers, with saucy torsos and garish graffiti (Je t'aime, Hard Luck, Mimi Chang, Adios Amigo). Runty Russians, too—one sees them about, flap-flapping in their pajama-like costumes. But the barefooted sailors on the beach, the three I saw reclining there, profiles set against the sundown, seemed mythical as mermen: more exactly, mermaids—for their hair, striped with albino streaks, was lady-length, a savage fiber falling to their shoulders; and in their ears gold rings glinted. Whether plenipotentiaries from the pearl-floored palace of Poseidon or mariners merely, Viking-tressed seamen out of the Gothic North languishing after a long and barberless voyage, they are included permanently in my memory's curio cabinet: an object to be revolved in the light that way and this, like those crystal lozenges with secretive carvings sealed inside.

After consideration, "Thunder on Cobra Street" does become decipherable. On the Heights there is no Cobra Street, though a street exists that suits the name, a steep down-hill incline leading to a dark sector of the dockyards. Not a true part of the Heights neighborhood, it lies, like a serpent at the gates, on the outmost periphery. Seedy hang-outs, beer-sour bars and bitter candy stores mingle among the eroding houses, the multi-family dwellings that architecturally range from time-blackened brownstone to mag-nified concepts of Mississippi privy.

Here, the gutters are acrawl with Cobras; that is, a gang of "juvenile" delinquents: COBRA, the word is stamped on their sweat shirts, painted, sometimes in letters that shine with a fearful phosphorescence, across the backs of their leather jackets. The steep street is within their ugly estate, a bit of their "turf," as they term it; an infinitesimal bit, for

the Cobras, a powerful cabala, cast owning eyes on acres of metropolitan terrain. I am not brave—*au contraire*; quite frankly these fellows, may they be twelve years old or twenty, set my heart thumping like a sinner's at Sunday meeting. Nevertheless, when it has been a matter of convenience to pass through this section of their domain, I've compelled my nerves to accept the challenge.

On the last venture, and perhaps it will remain the last, I was carrying a good camera. The sun was unseen in a sky that ought to either rumble or rain. Rackety children played skip-rope, while a lamppost-lot of idle elders looked on, dull-faced and drooping: a denim-painted, cowboy-booted gathering of Cobras. Their eyes, their asleep sick insolent eyes, swerved on me as I climbed the street. I crossed to the opposite curb; then *knew*, without needing to verify it, that the Cobras had uncoiled and were sliding toward me. I heard them whistling; and the children hushed, the skip-rope ceased swishing. Someone—a pimpled purple birthmark bandit-masked the lower half of his face—said, "Hey yuh, Whitey, lemmeseeduhcamra." Quicken one's step? Pretend not to hear? But every alternative seemed explosive. "Hey, Whitey, hey yuh, takemuhpitchawantcha?"

Thunder salvaged the moment. Thunder that rolled, crashed down the street like a truck out of control. We all looked up, a sky ripe for storm stared back. I shouted, "Rain! Rain!" and ran. Ran for the Heights, that safe citadel, that bourgeois bastion. Tore along the Esplanade—where the nice young mothers were racing their carriages against the coming disaster. Caught my breath under the thrashing leaves of troubled elms, rushed on: saw the flower-wagon man struggling with this thunder-frightened horse. Saw, twenty yards ahead, then ten, five, then none, the yellow house on Willow Street. Home! And happy to be.

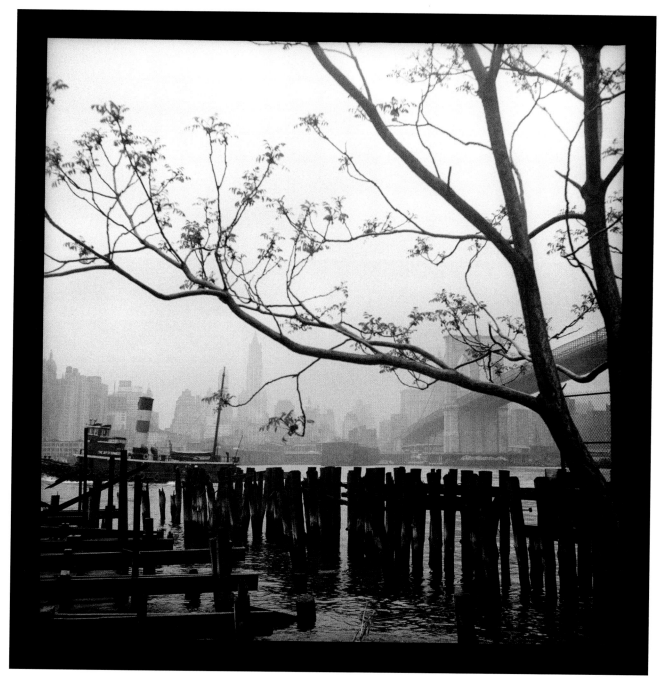

TUGBOAT

Brooklyn
1958

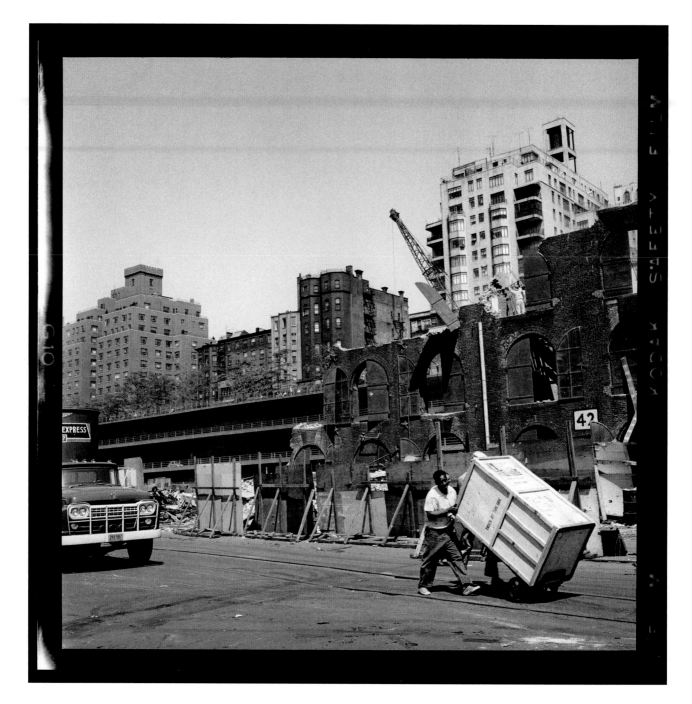

CRATE

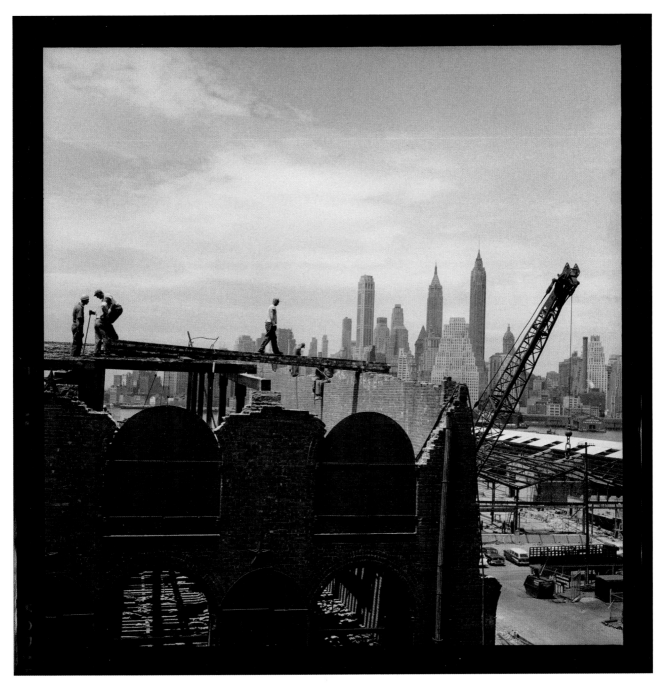

BEAM

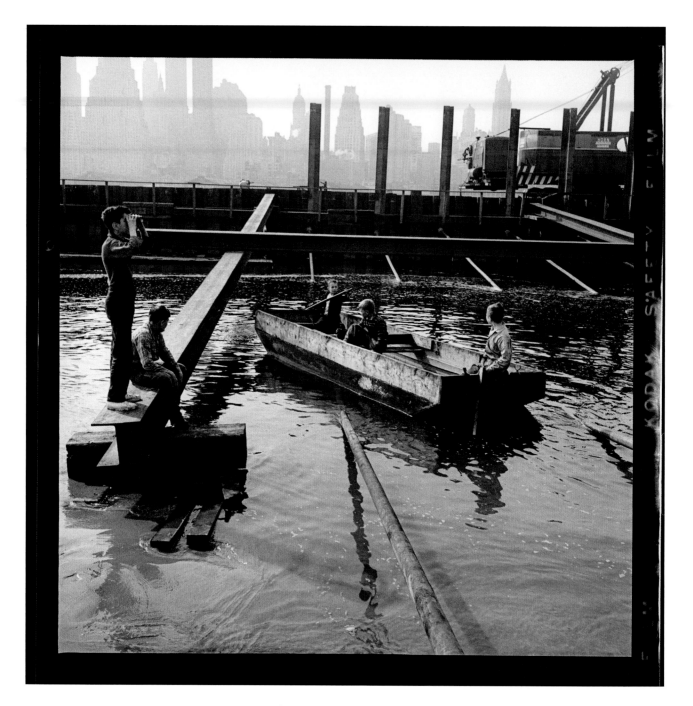

ON THE WATERFRONT

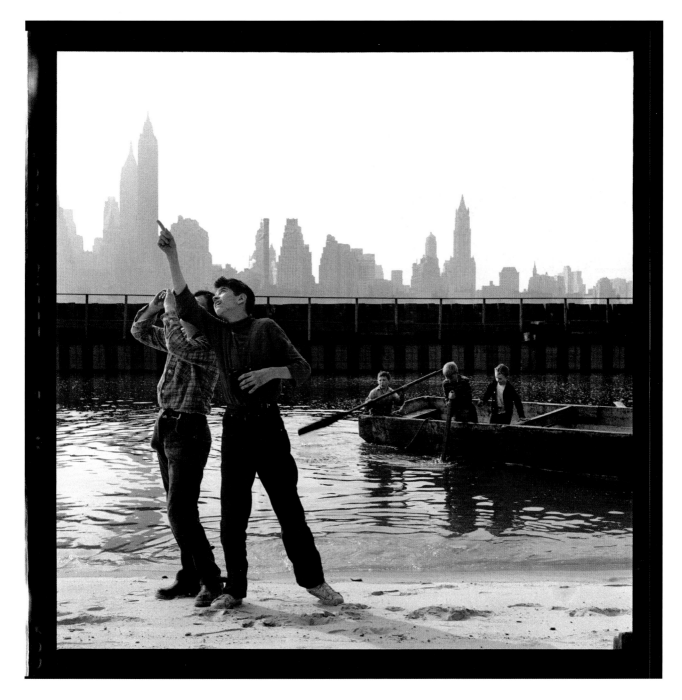

LOOK!

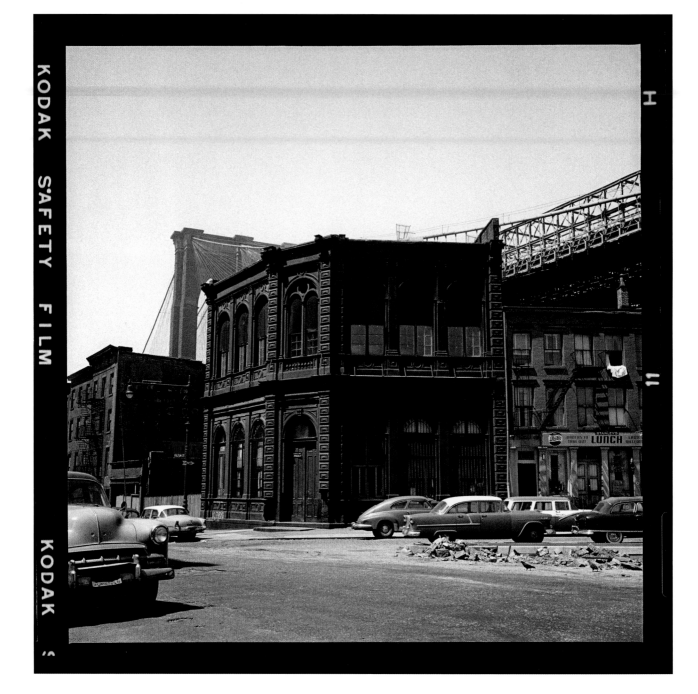

FRONT STREET

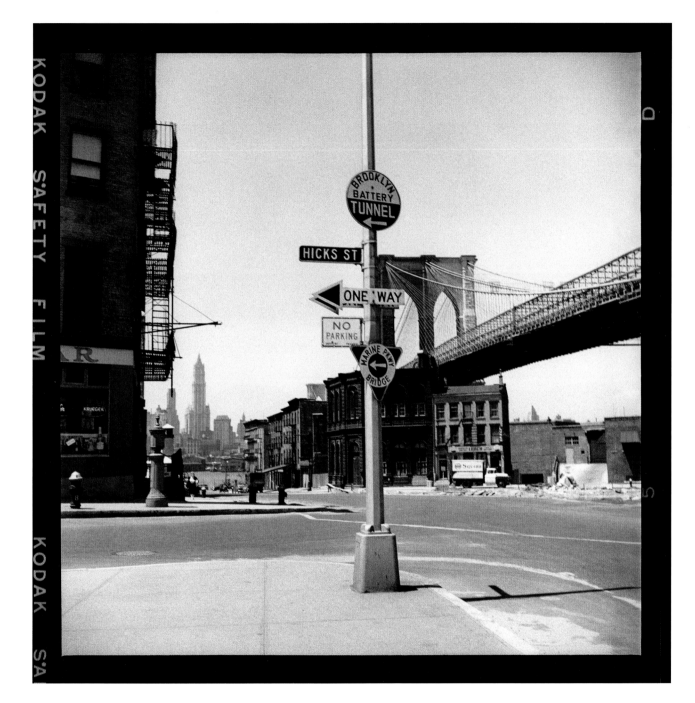

HICKS STREET

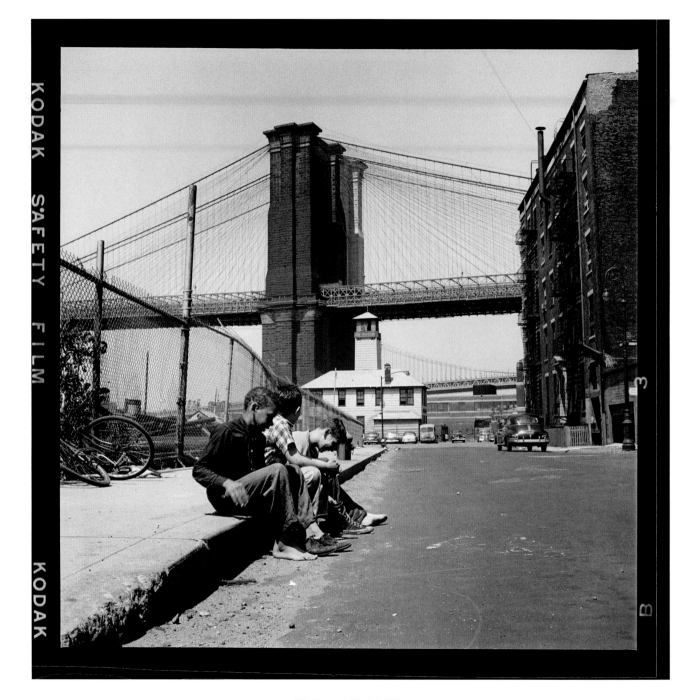

SHOES AND SOCKS

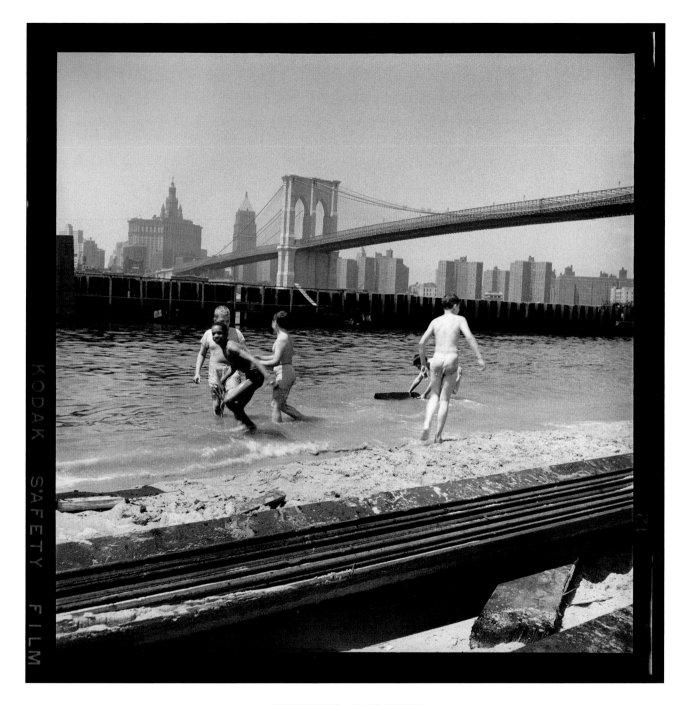

SWIMMING, EAST RIVER

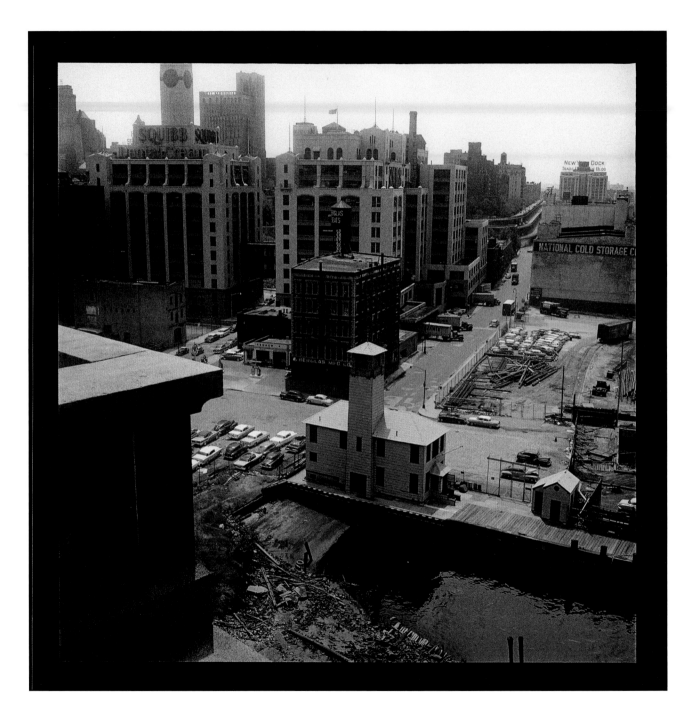

ENGINE CO. 77

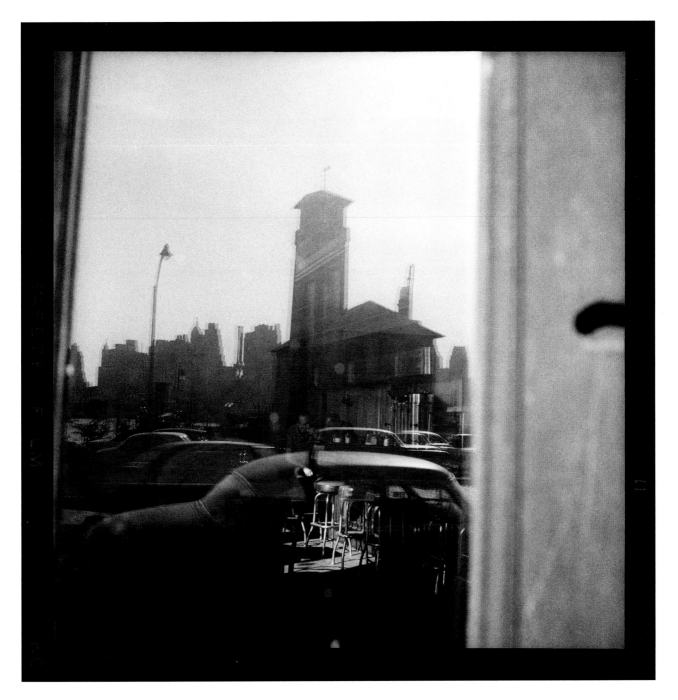

ENGINE CO. 77, REFLECTION

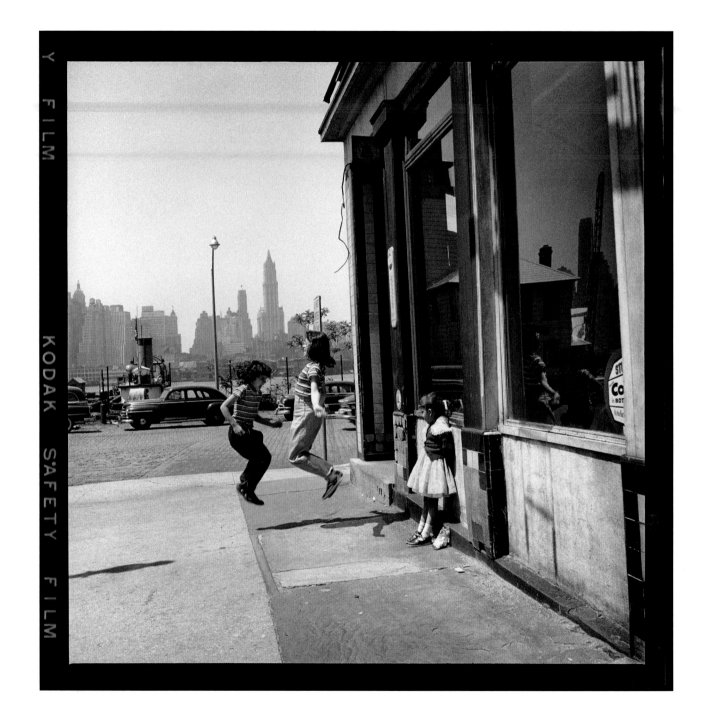

JUMP ROPE

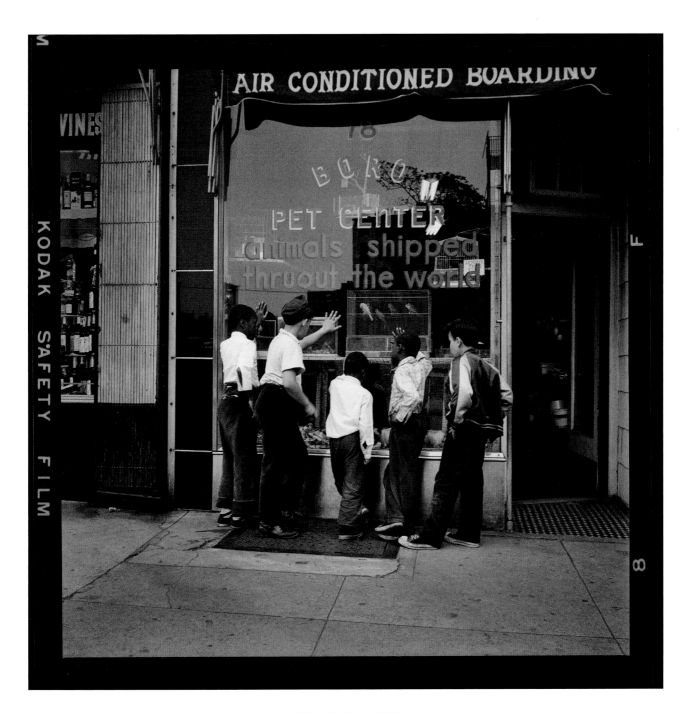

BORO PET CENTER

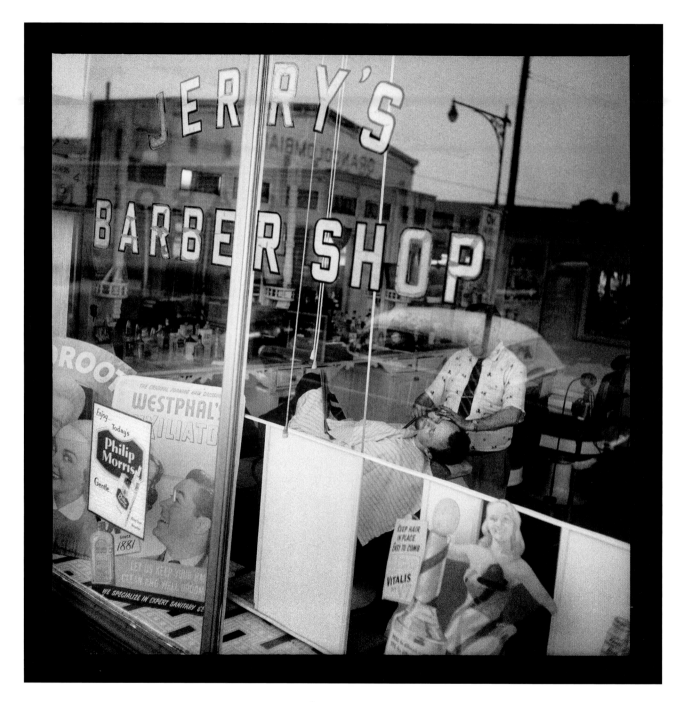

JERRY'S BARBER SHOP

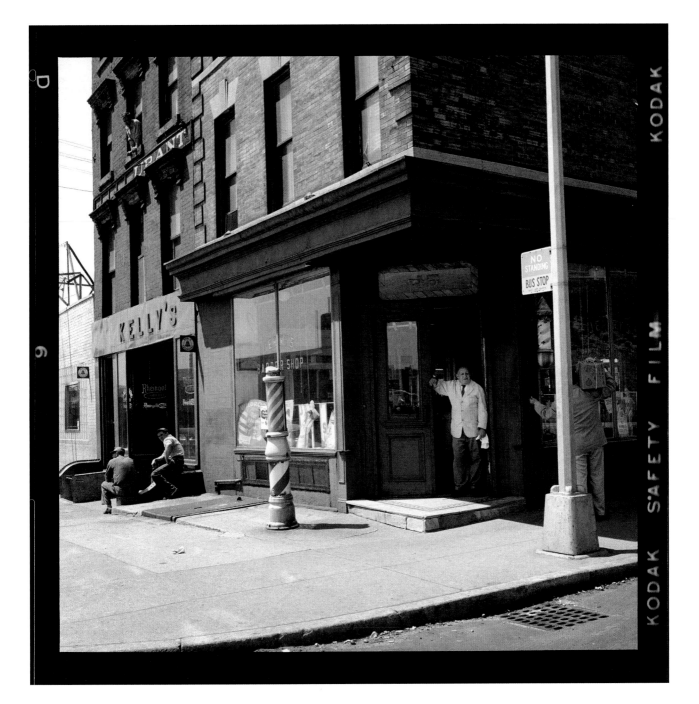

JERRY

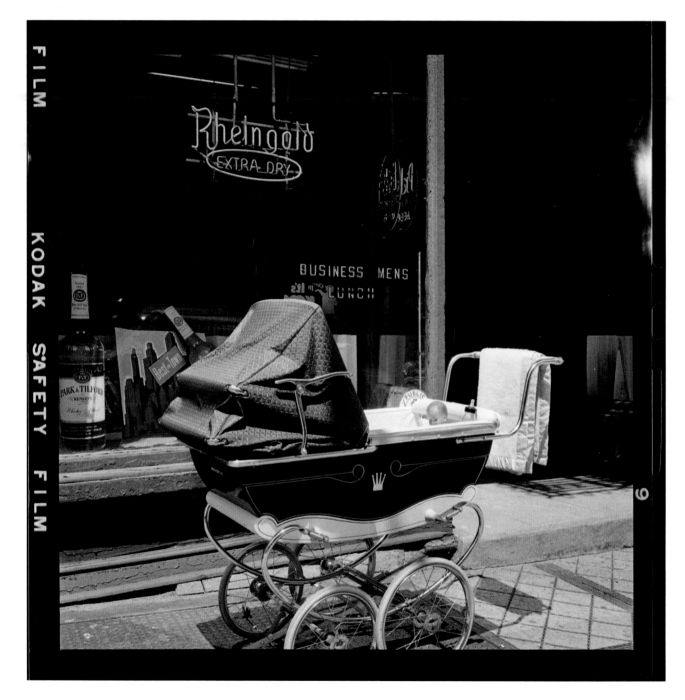

BUSINESS MENS LUNCH I

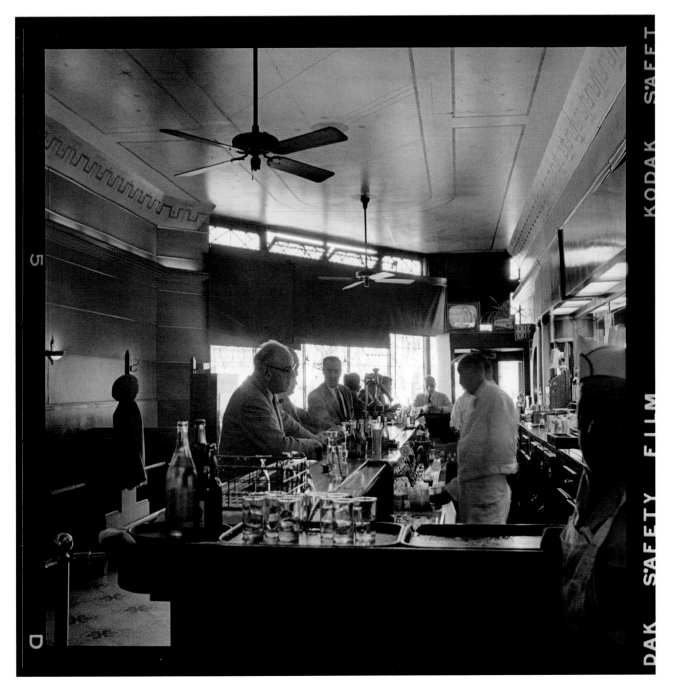

BUSINESS MENS LUNCH II

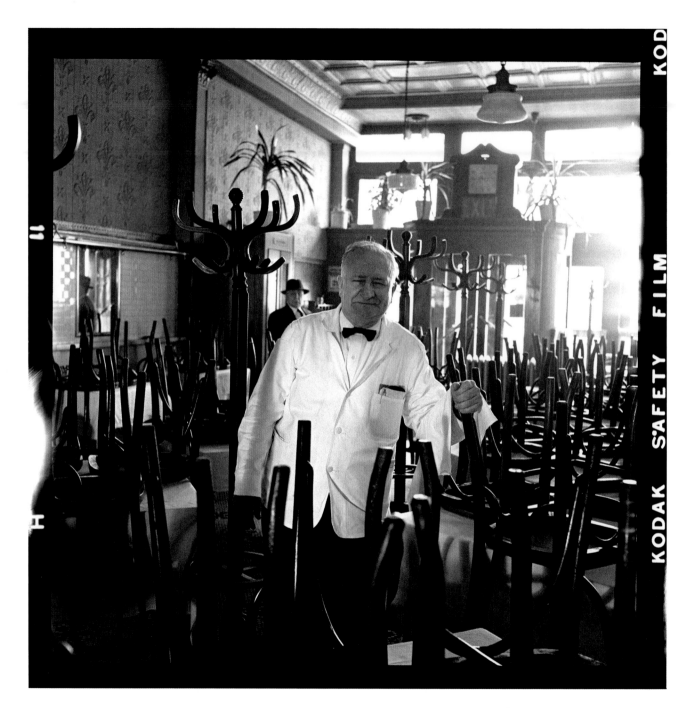

WAITER I

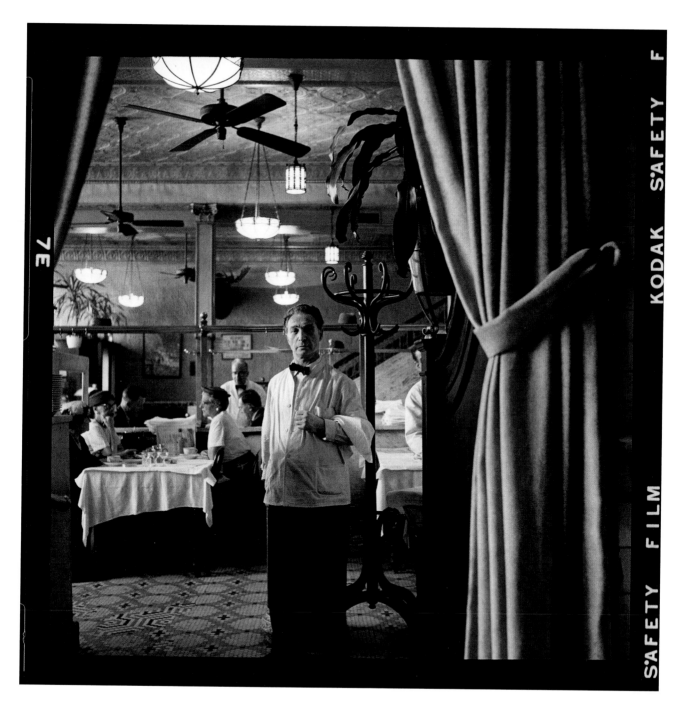

WAITER II

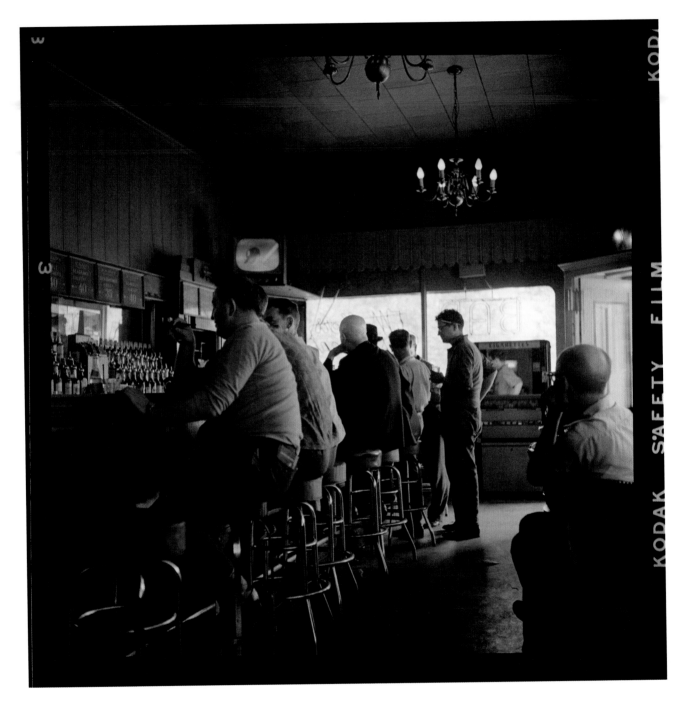

BAR AND BASEBALL

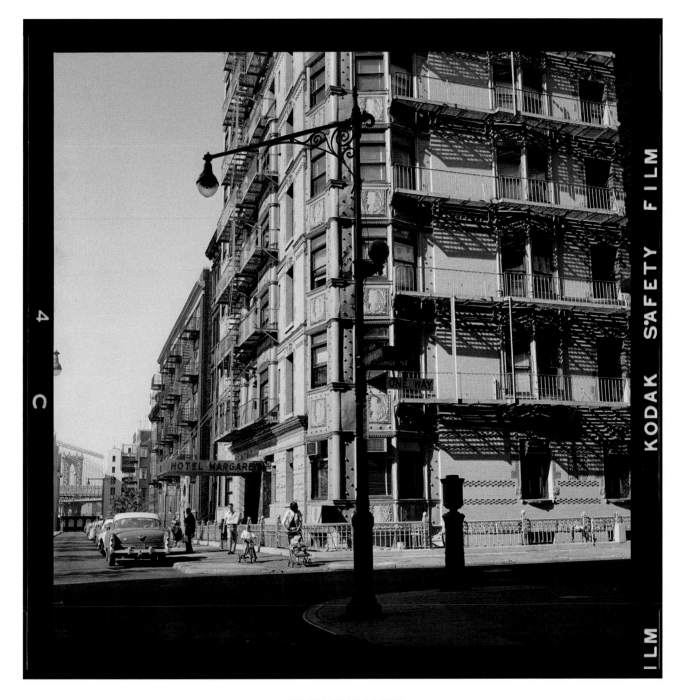

HOTEL MARGARET

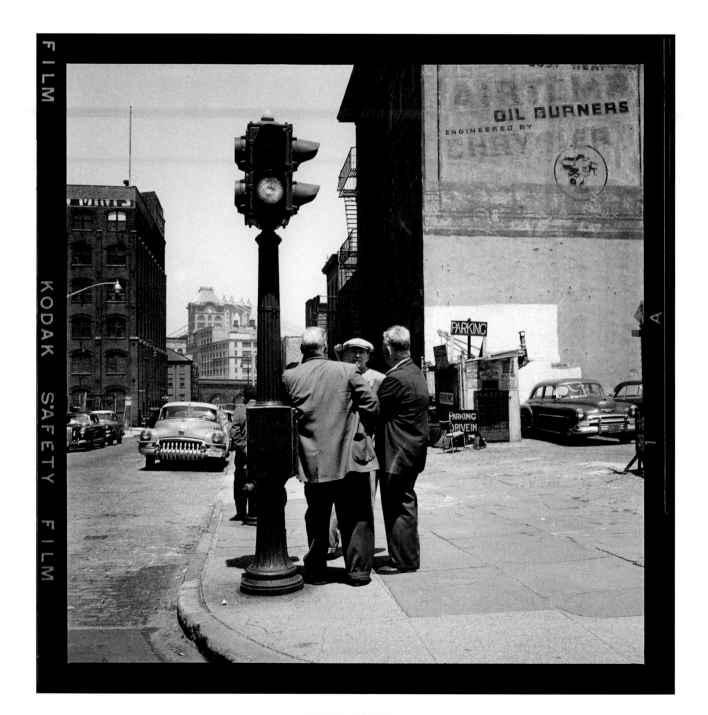

STREET CORNER

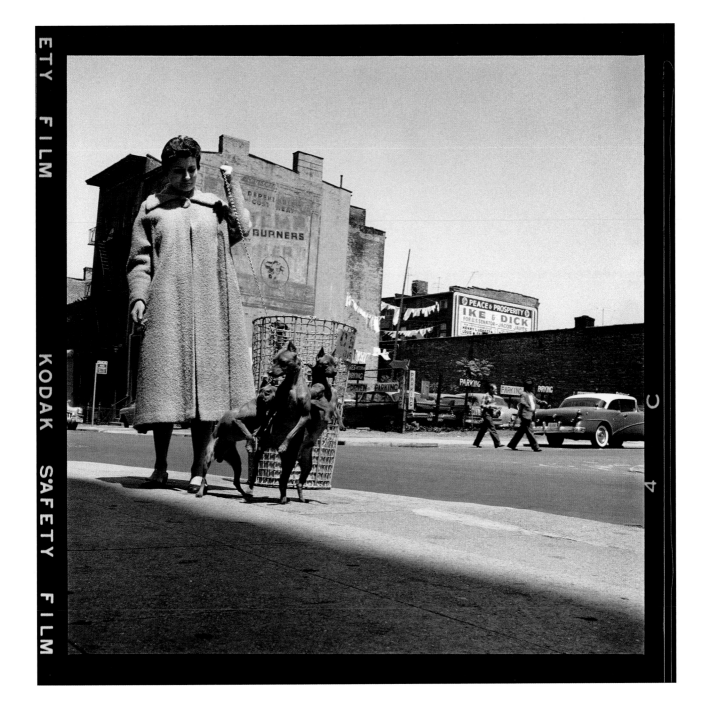

THREE DOGS

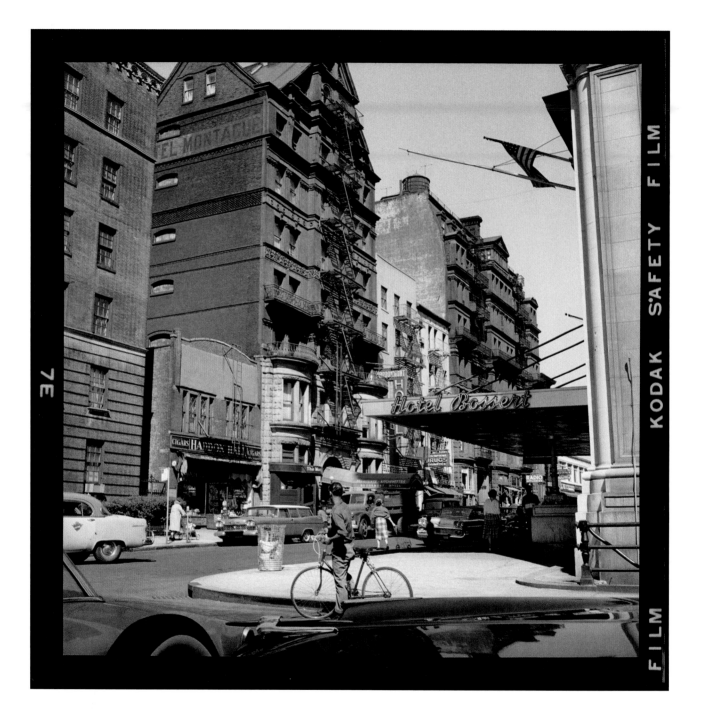

HOTEL BOSSERT

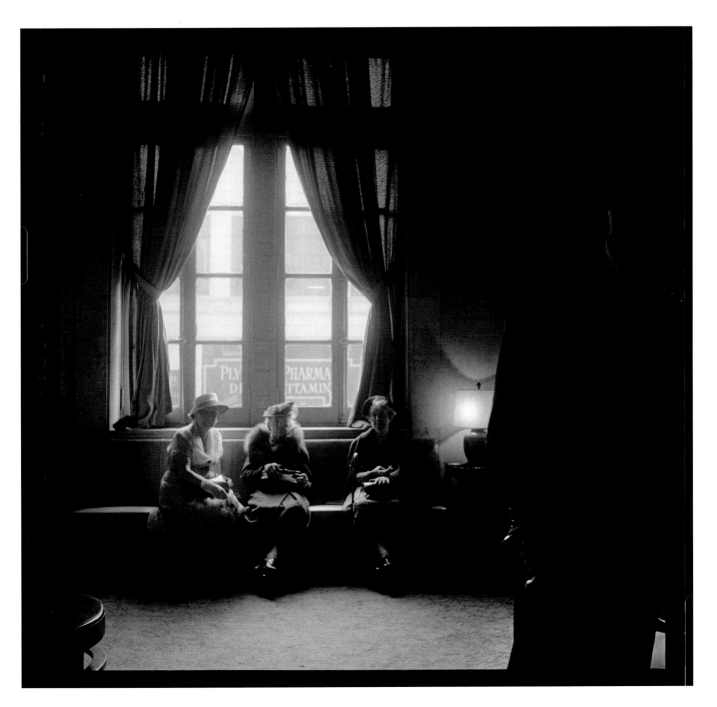

LOBBY, HOTEL BOSSERT

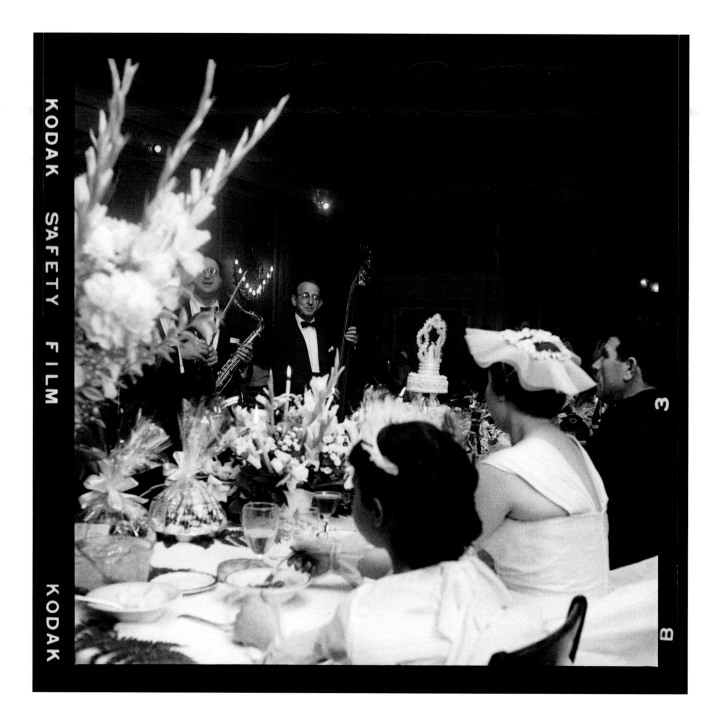

RECEPTION I

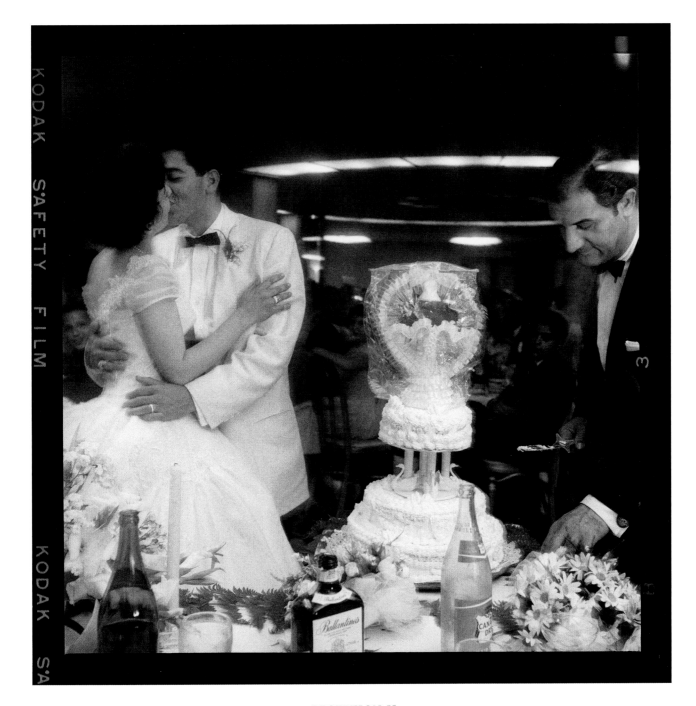

RECEPTION II

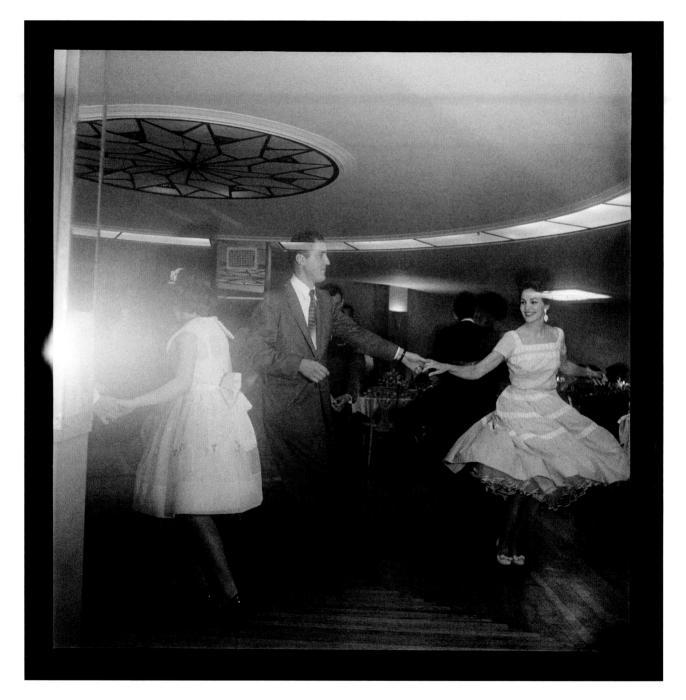

RECEPTION III

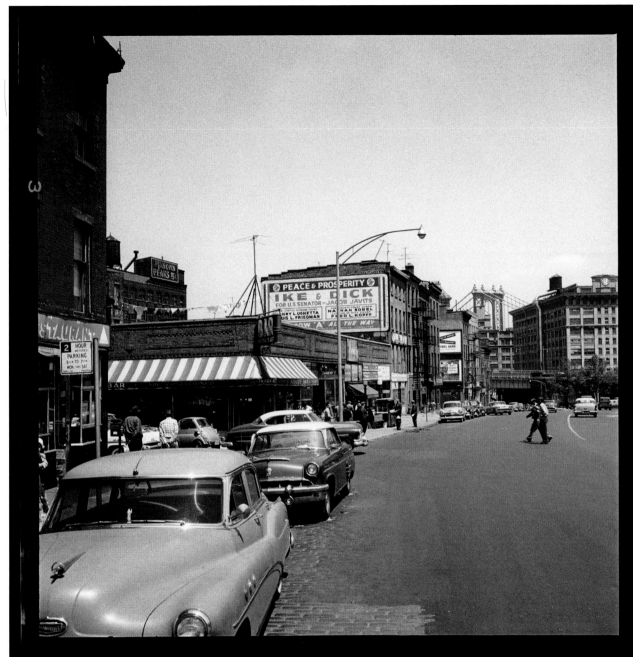

PEACE & PROSPERITY

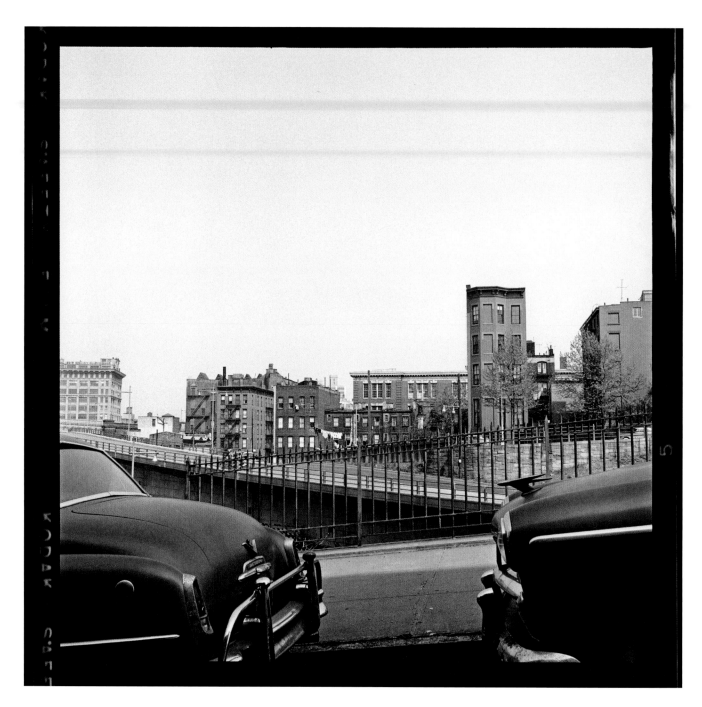

HOOD ORNAMENT

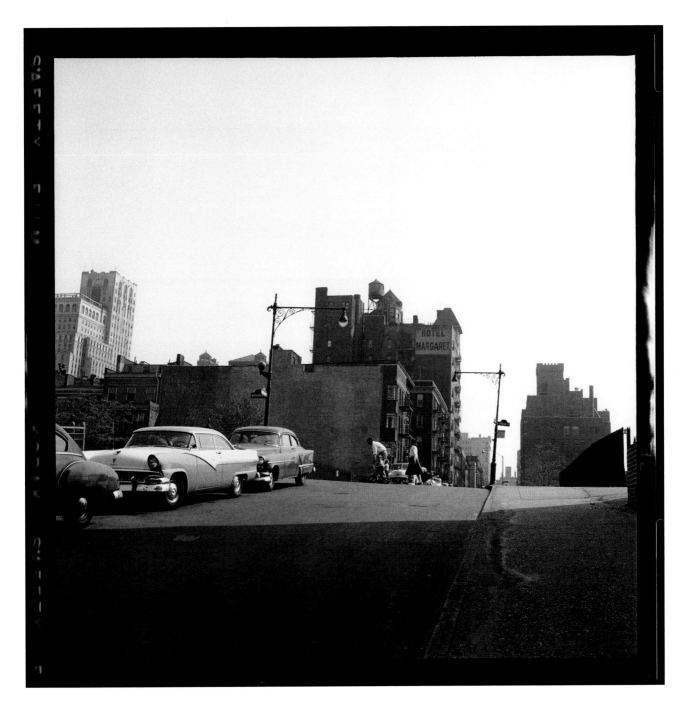

CROSSING THE STREET

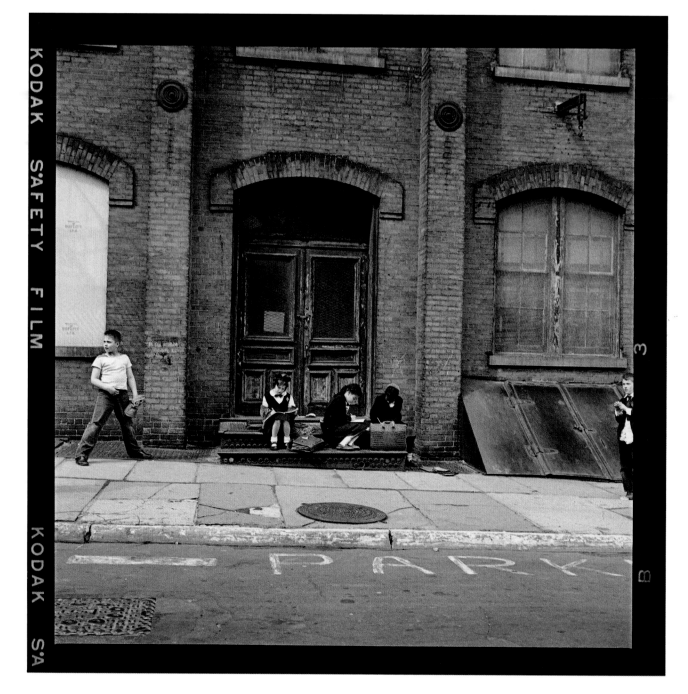

HOMEWORK

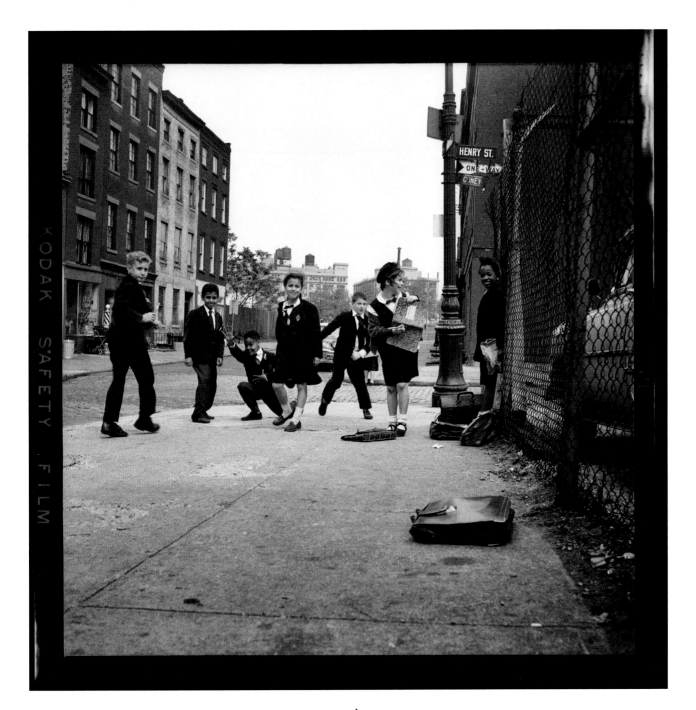

SCHOOL'S OUT

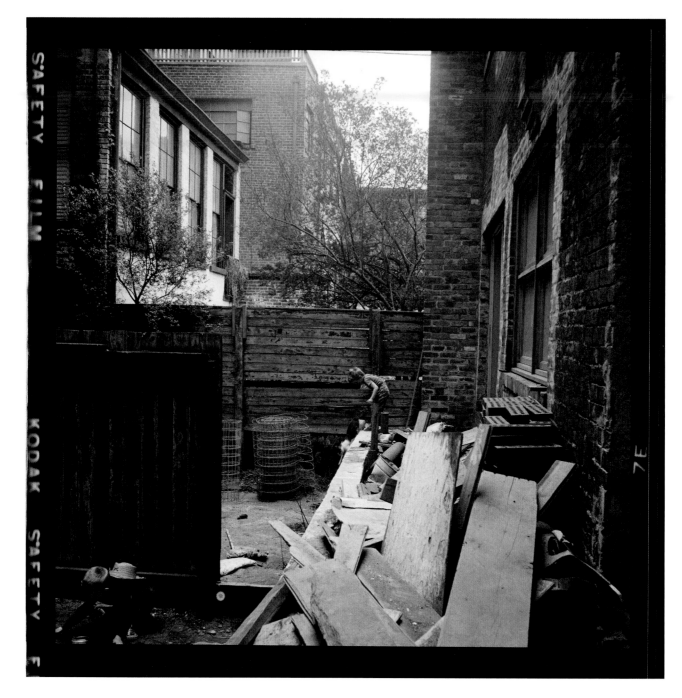

PLAYING OUT BACK

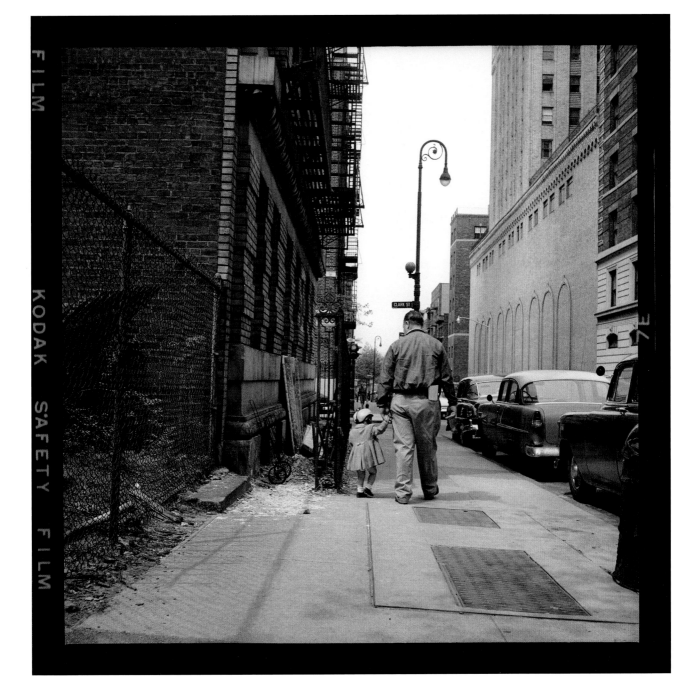

OUT FOR A STROLL

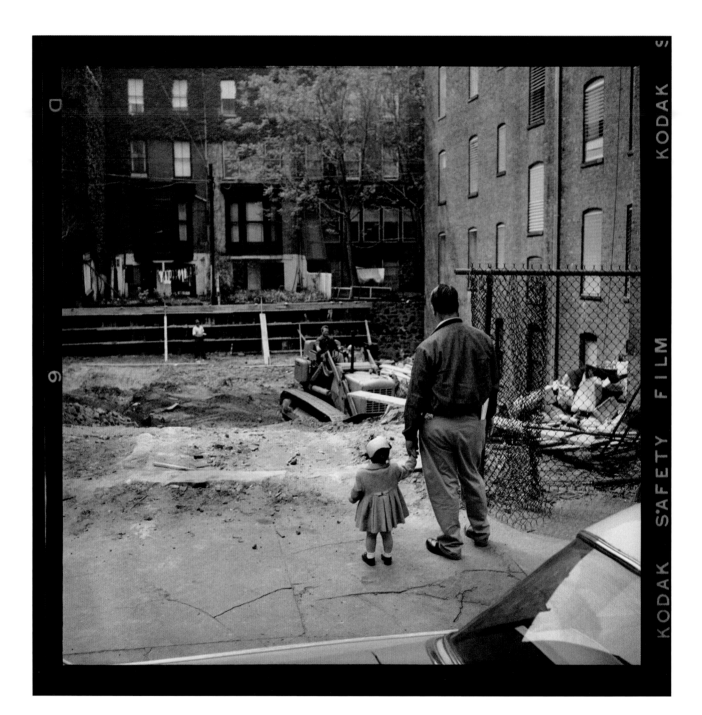

BULLDOZER I

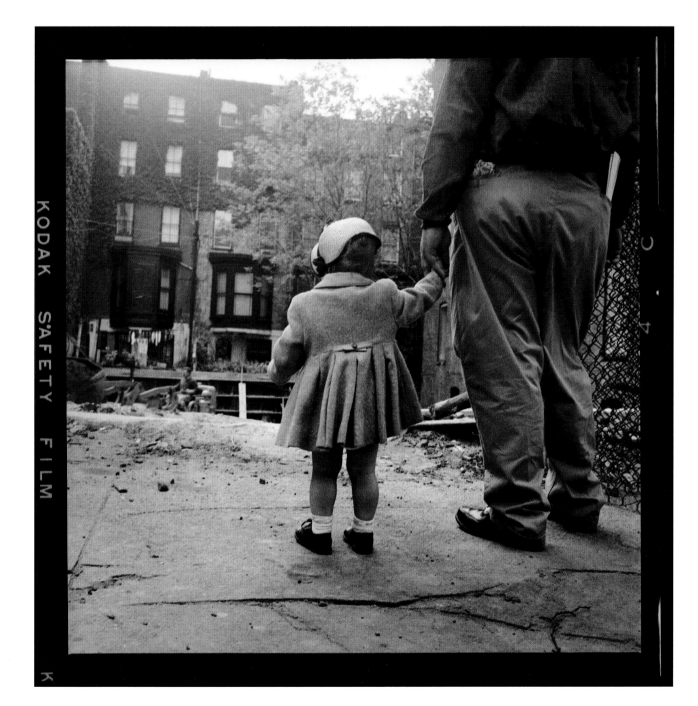

BULLDOZER II

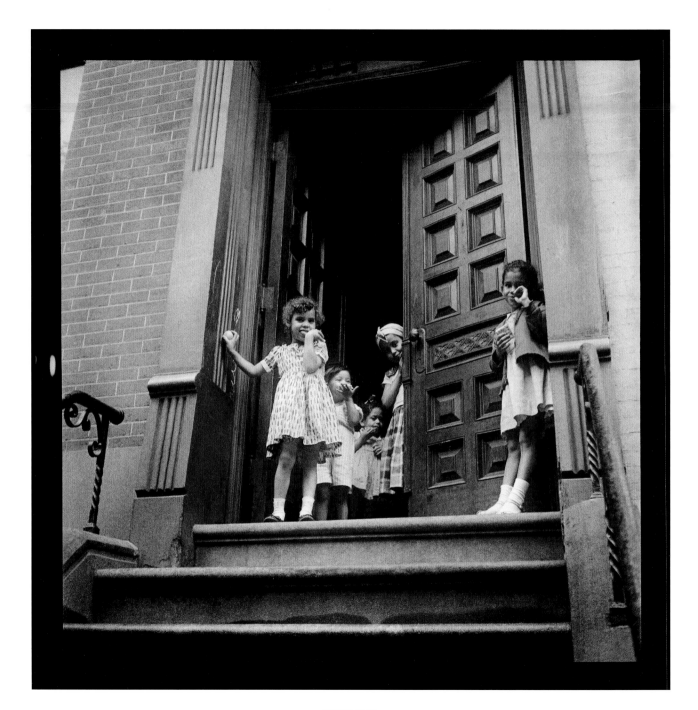

COUSINS

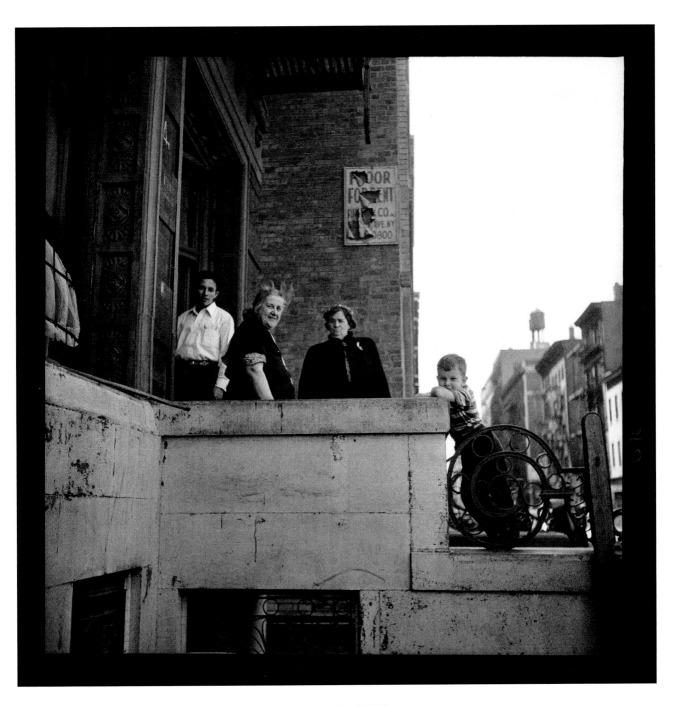

FLOOR FOR RENT

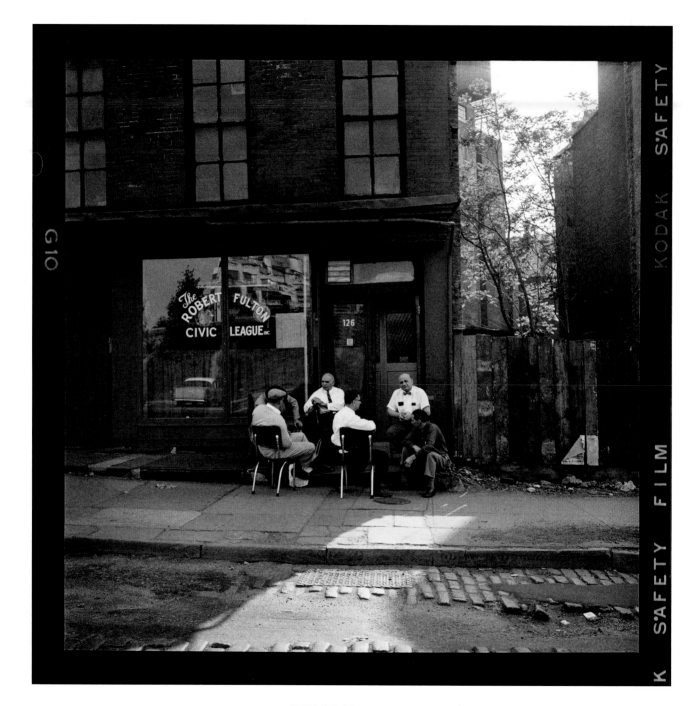

THE CIVIC LEAGUE

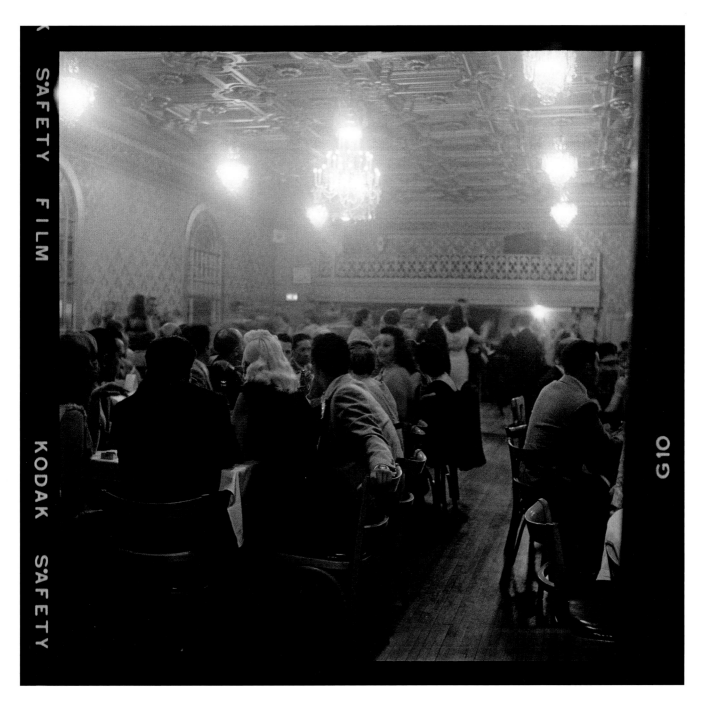

NIGHTCLUB

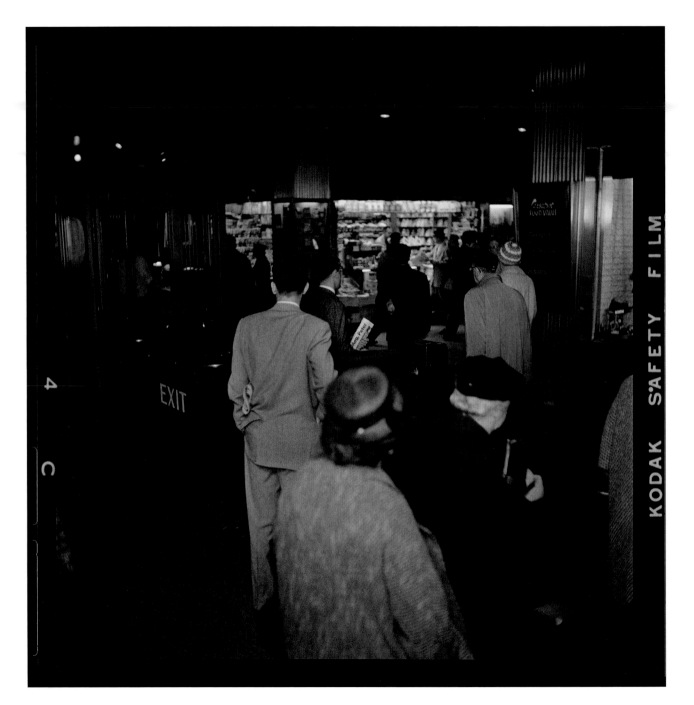

SUBWAY STATION

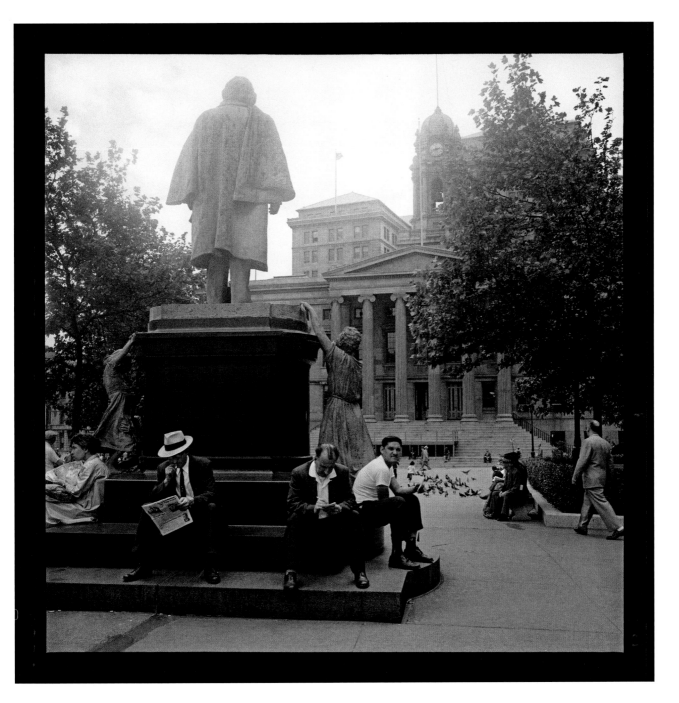

BOROUGH HALL

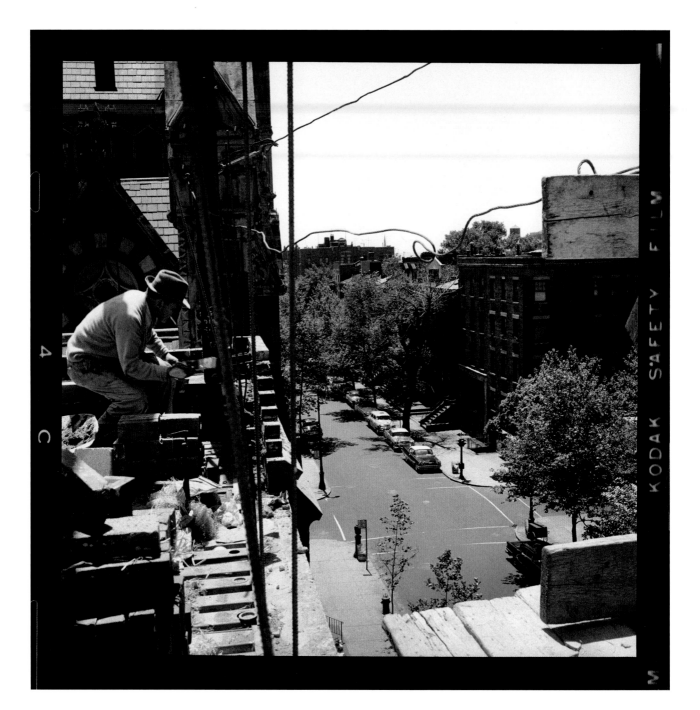

BRICKLAYER

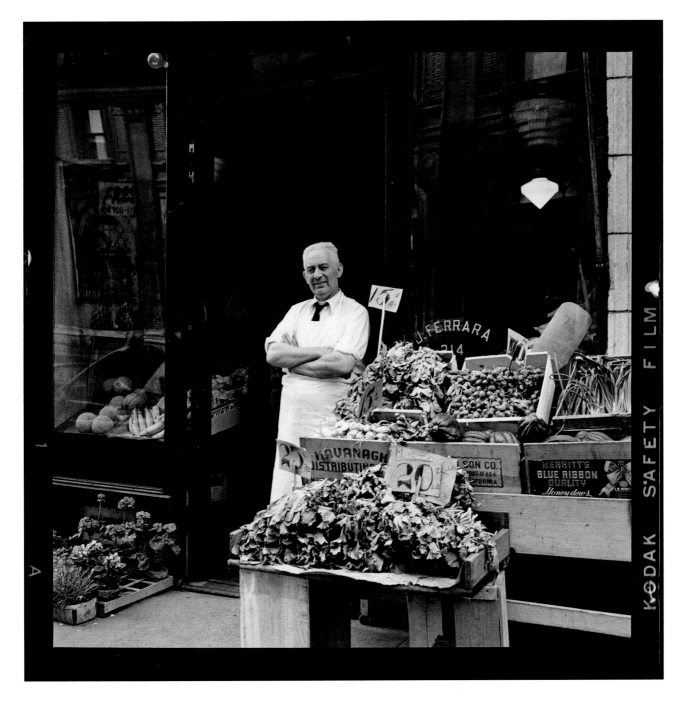

J. FERRARA

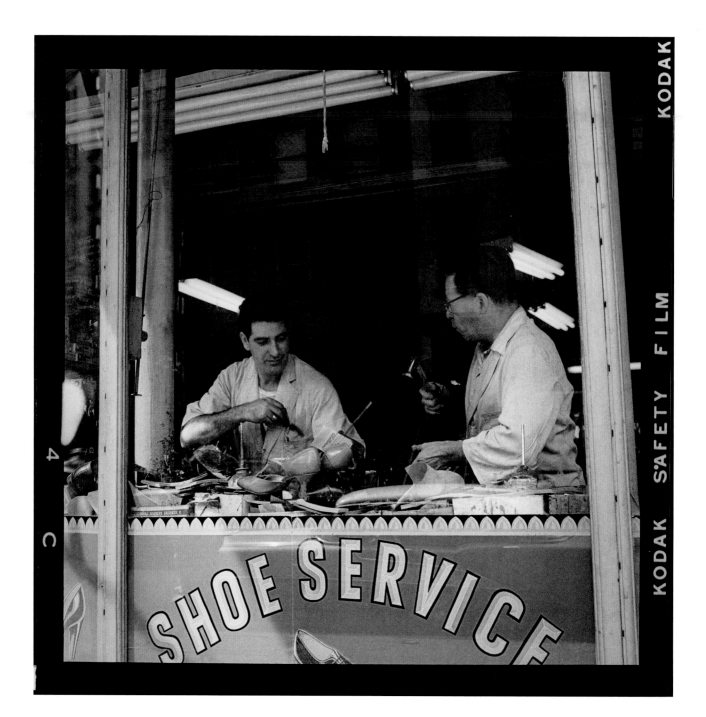

SHOE SERVICE

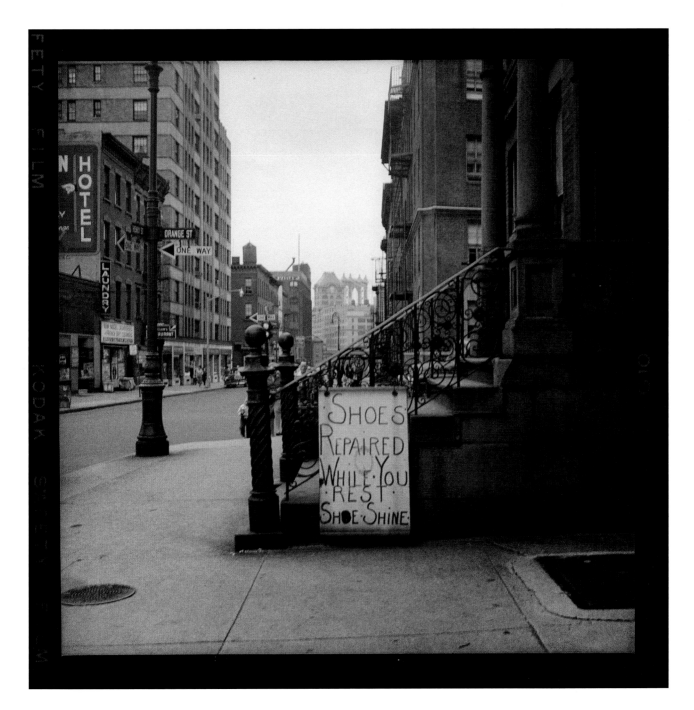

WHILE YOU REST

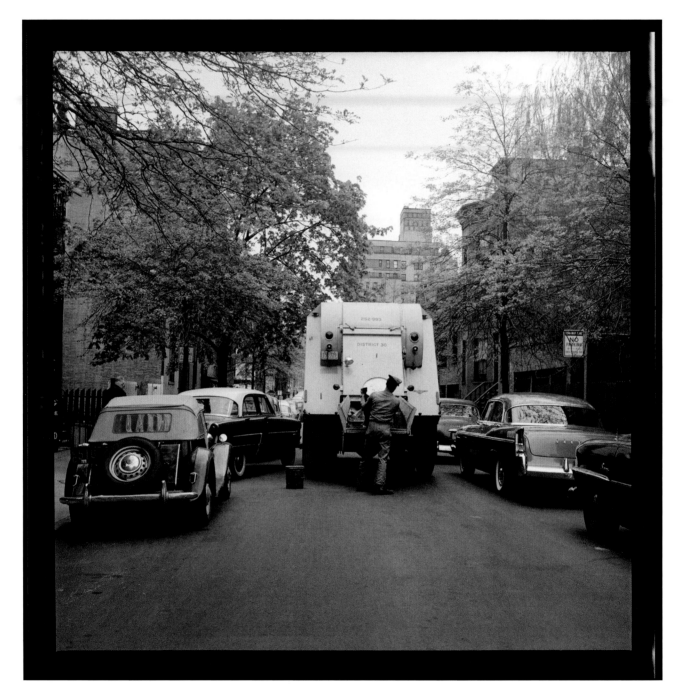

D.S.N.Y.

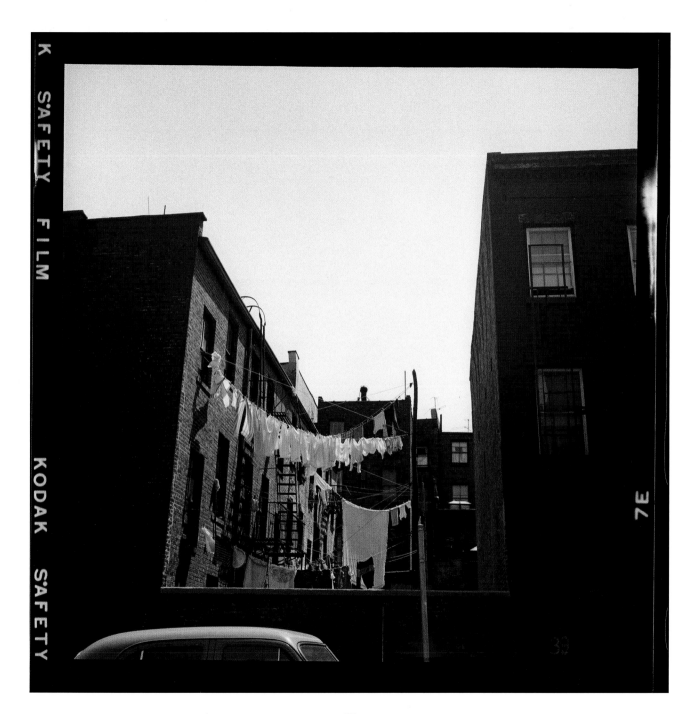

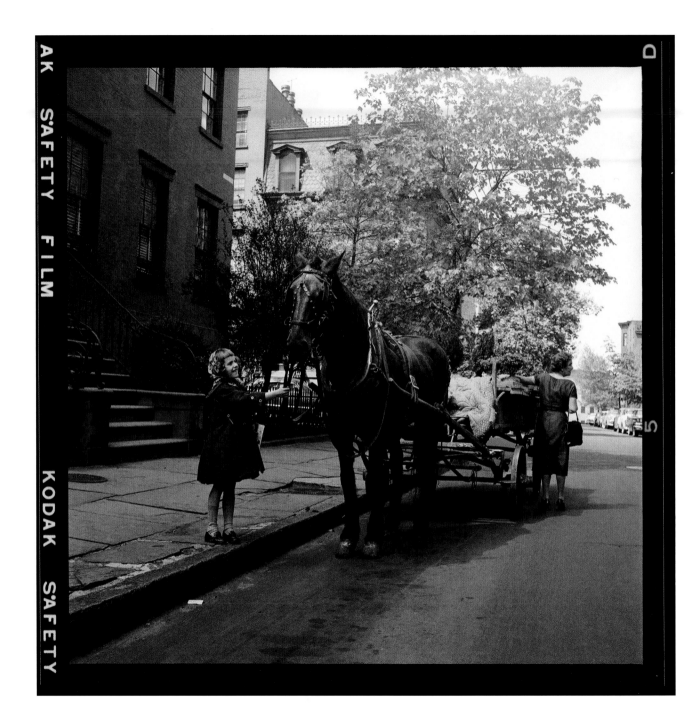

FLOWER WAGON I

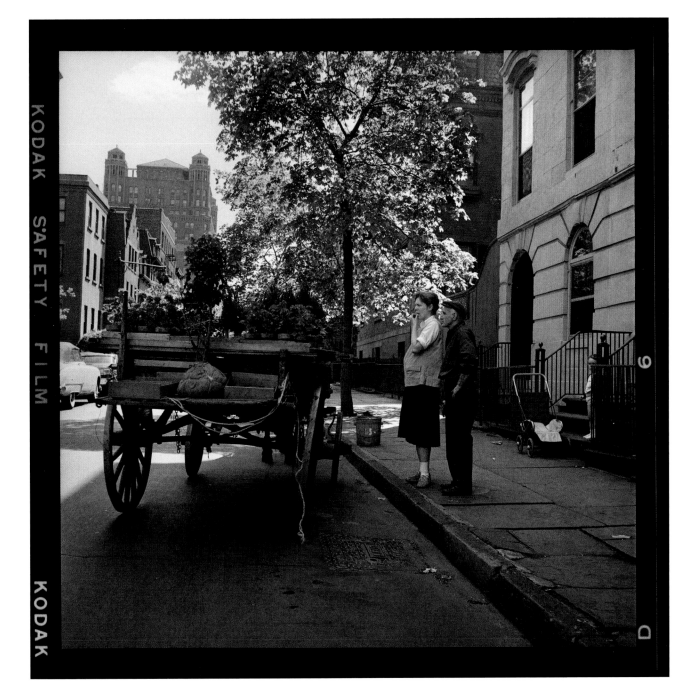

FLOWER WAGON II

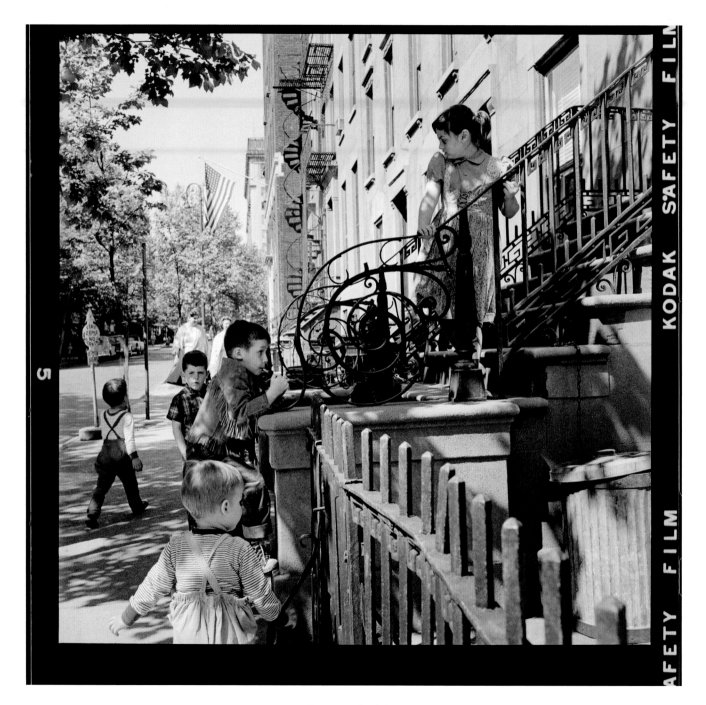

ON THE STOOP

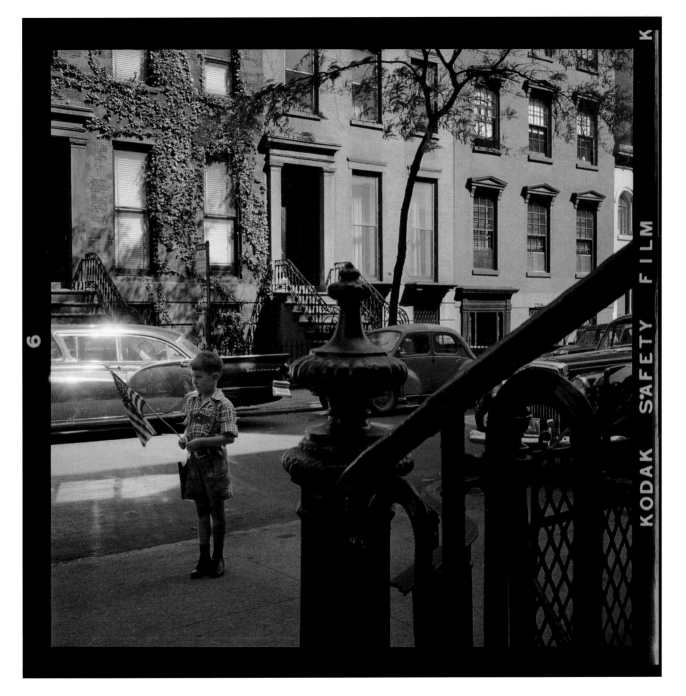

FLAG

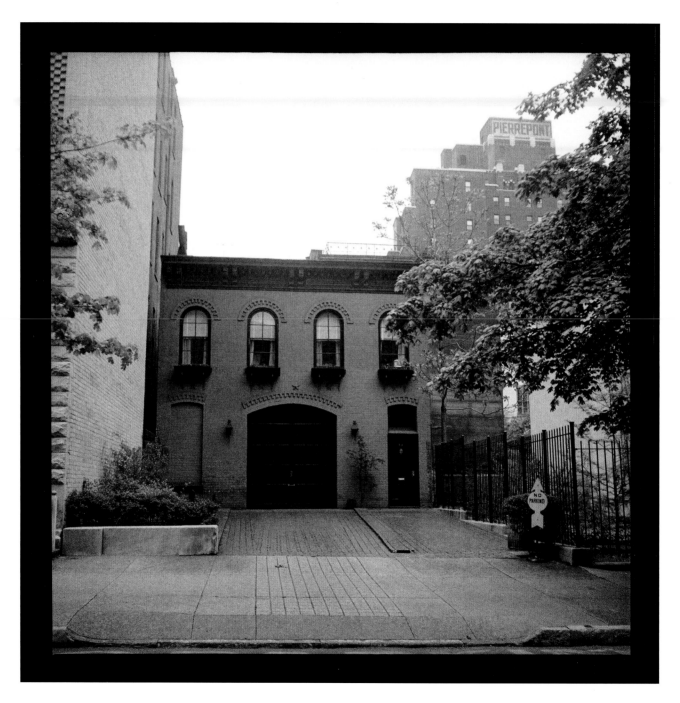

CARRIAGE HOUSE

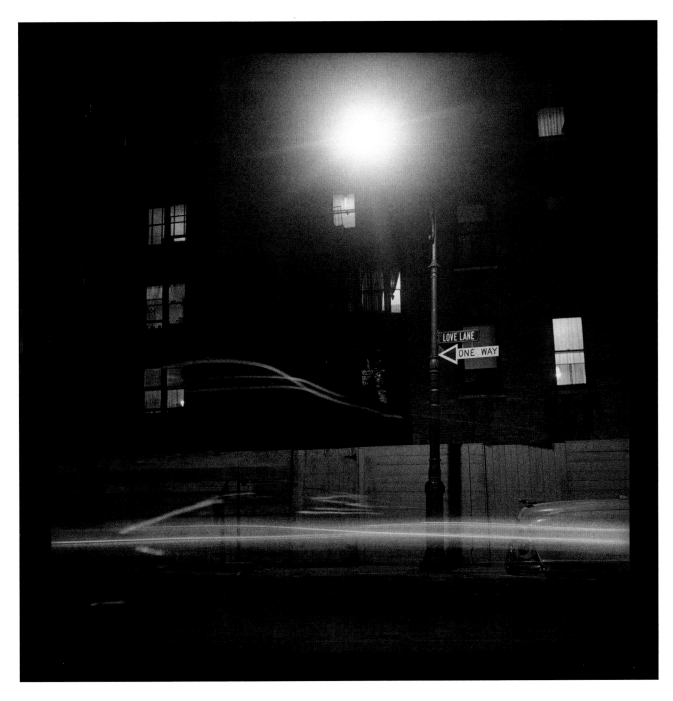

LOVE LANE

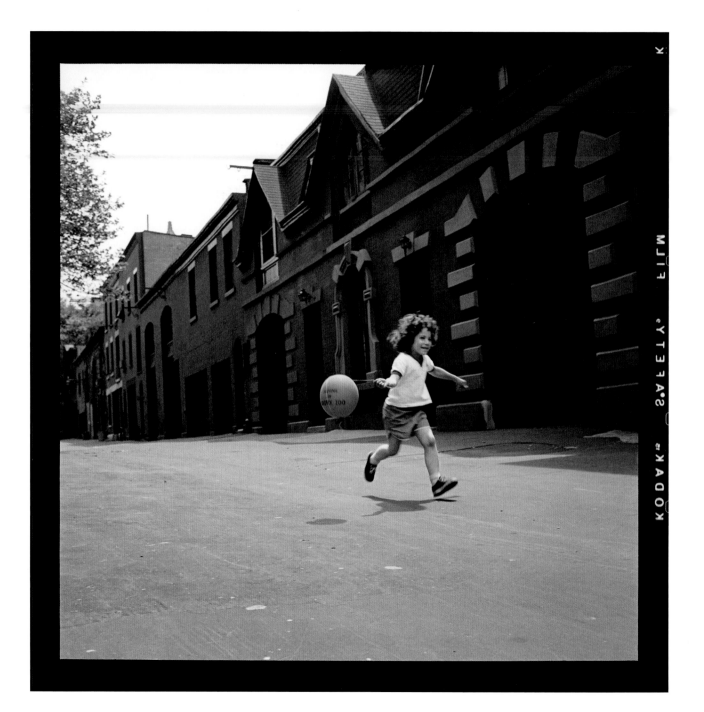

BALLOON

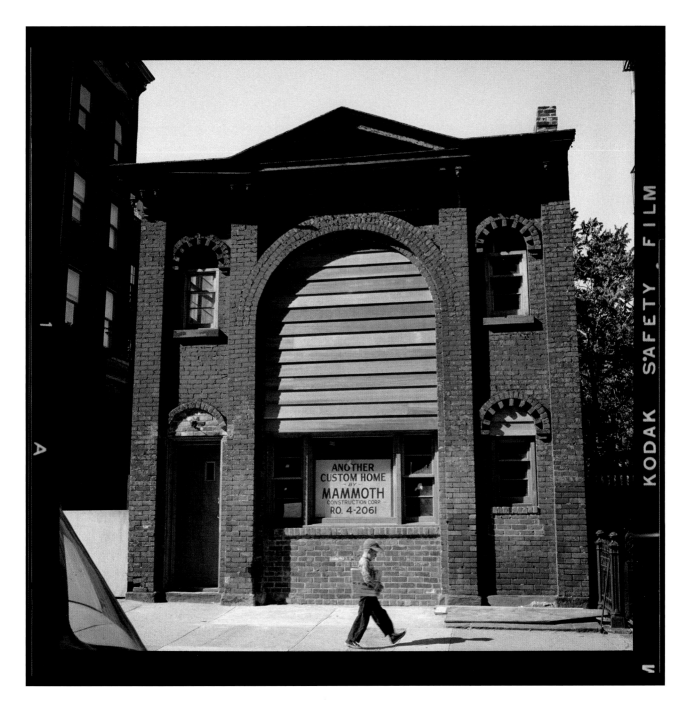

ANOTHER CUSTOM HOME

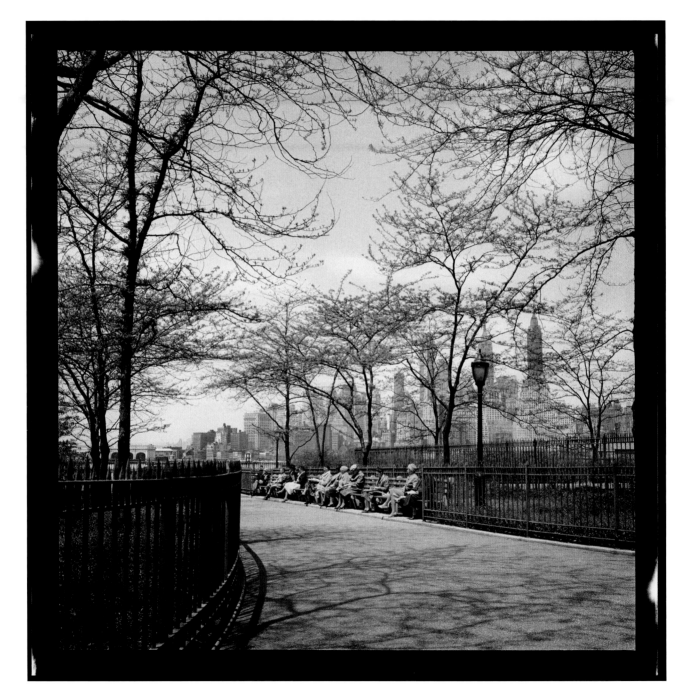

SPRING

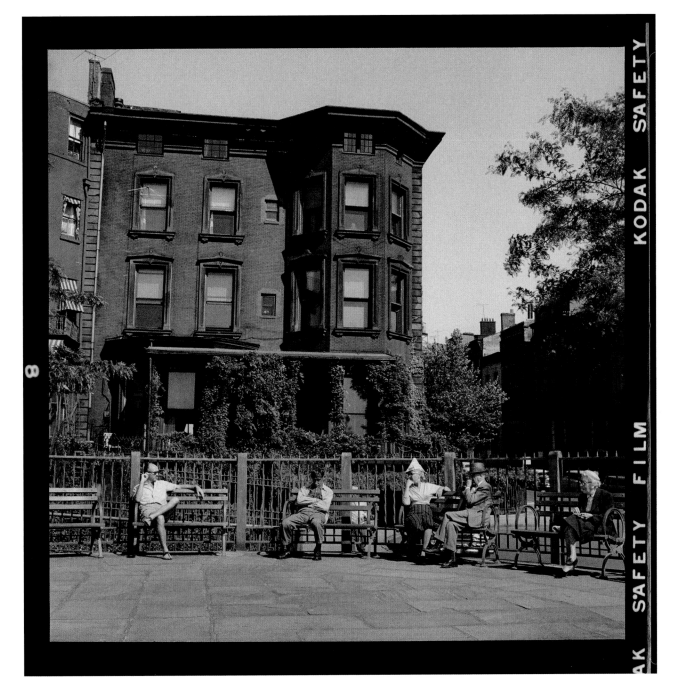

WARM WEATHER

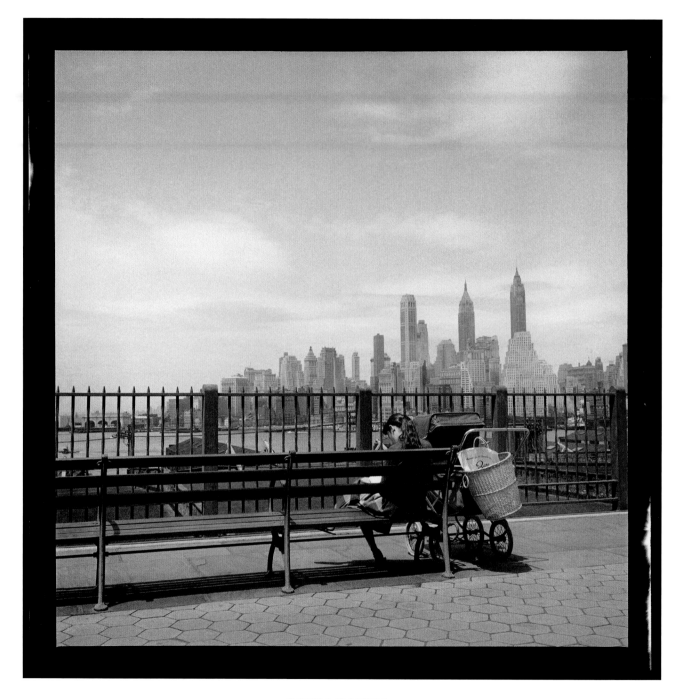

YOUNG MOTHER

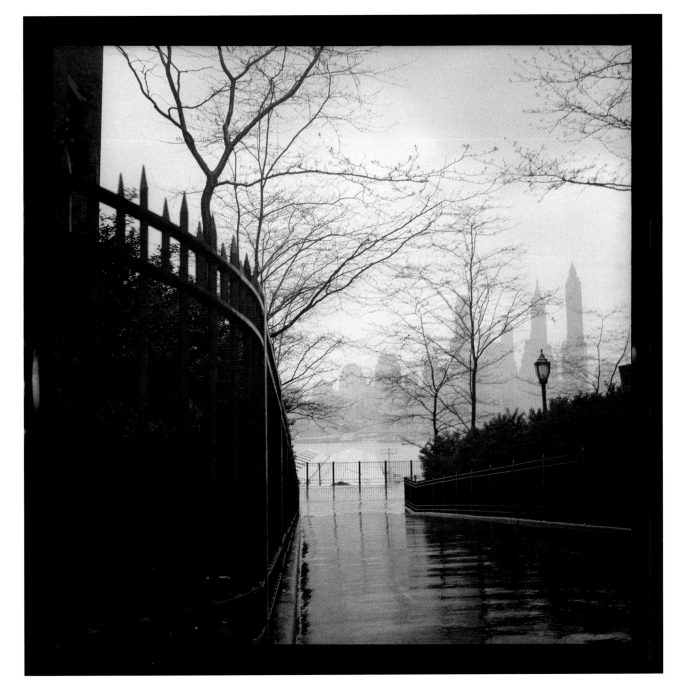

SPRING RAIN

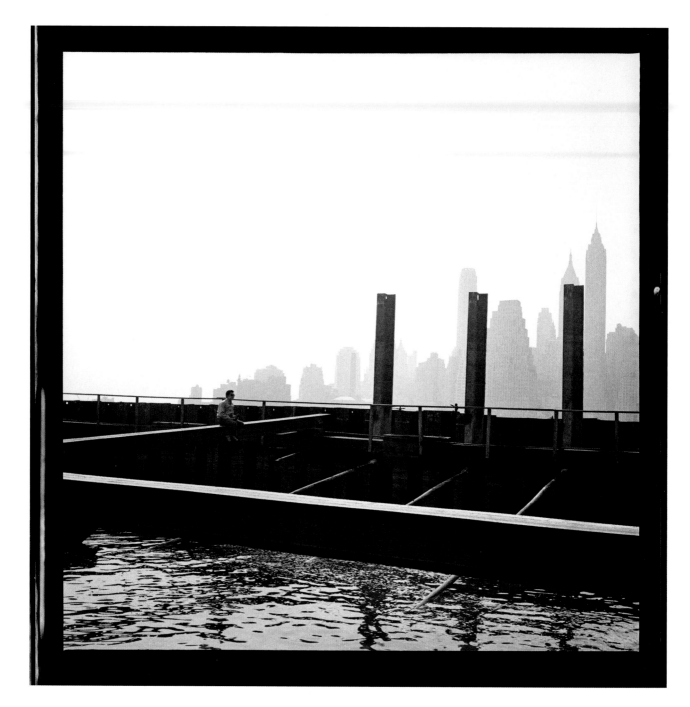

AFTERNOON

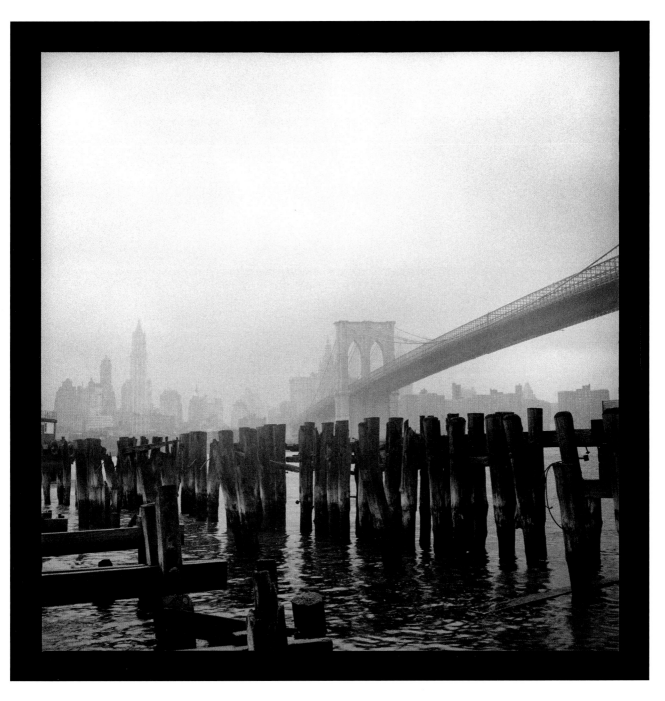

PILINGS, BROOKLYN BRIDGE

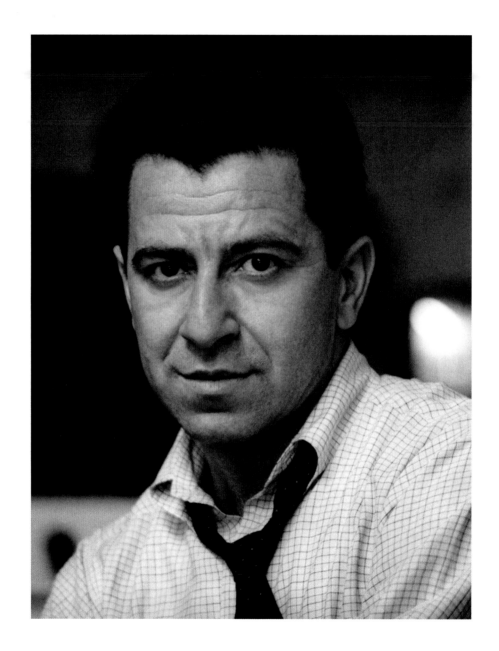

DAVID ATTIE

Afterword

ELI ATTIE

Truman Capote effectively launched my father's career. Which is something I learned five months ago, decades after my father's death.

If that seems odd to you, well, it's odd to me, too. The road to this book has been filled with strange accidents, surprising discoveries, and incredible good fortune.

And oh yeah, the brilliant work of David Attie.

At this point you're probably wondering: Who the hell was David Attie?

My father was a steadily working commercial photographer for about twenty-five years. He was a student and protégé of the famed art director Alexey Brodovitch—who had similarly mentored the careers of Richard Avedon and Irving Penn—and his work appeared on magazine covers, book jackets, even subway posters throughout my childhood. He had gallery shows, published a beautiful book of photographs he took in the Soviet Union, and landed prints in the National Portrait Gallery.

Then he passed away, in the early '80s, nearly a decade before the Internet, which turned out to be a uniquely modern curse. Because, at a time when you could claim notoriety for posting videos of kittens climbing out of cardboard boxes, my father and his work had all but vanished.

I discovered this three years ago when, in a moment of procrastination from my own work as a television writer, I googled my father's name. Not much turned up. One of the few things that did was a blog post with two Pall Mall cigarette ads he'd drawn in the 1950s, when he was a commercial illustrator, followed by the cover of a trashy pulp novel he'd drawn around the same time, followed by this statement: "And for now, that's all we know about David Attie."

So I posted a brief comment. I said that I was a direct relative, and that, actually, David Attie became a photographer and had a great career. I signed it "Eli." And then I went back to whatever script I was trying not to write.

Within a couple days, I was contacted (on Twitter, no less) by a guy named Brian Homer—a lovely man from England, who had bought my father's book, *Russian Self-Portraits*, had been influenced by it, and wanted to help get his work seen again. My first reaction was: Why hadn't I ever thought of that? Weeks later, we met in New York, and along with my brother Oliver and my mother Dotty Attie (a gifted, successful painter in her own right), spent a few days rifling through the dust-covered wooden boxes that contain my father's negatives—exactly as he left them, in the Manhattan brownstone that was his home and studio, and where my mother still lives and works today.

Brian was mostly interested in the Russian self-portraits, so that's what we looked for and organized. But I stumbled across something that interested me more: stunning studio portraits of The Band, at their peak in 1969, taken for the cover of *Time* magazine but never used. (Ironically, their thickly whiskered, Civil-War-troubadour look is closer to contemporary Brooklyn than anything in this book.) Being a bit of a rock obsessive, I decided to take the negatives back home to Los Angeles, where I was sure I could get them published and exhibited and permanently enshrined in popular culture.

Two things happened right away: 1) I left the negatives in a taxicab (and quickly recovered them, thanks to a high school pal who happened to be the Deputy Commissioner of Transportation); 2) Nobody cared that I had a few rolls of film by a long-dead photographer.

Actually, that's putting it mildly. I couldn't even get gallerists and curators on the phone for general advice. Hollywood may be a tough town, but at least people will ignore you over coffee. Brian's luck wasn't any better. Finally, a prominent rock photographer told me: "You need more famous people. Gather any pictures your father took of famous people. That's the only way anyone's ever gonna care." On my next trip to New York, I went back to the dust-covered wooden boxes.

That's when I found a small manila envelope labeled "Holiday, Capote, A3/58." Now, I knew that my father had photographed some notables in his time—including Bobby Fischer and Leonard Bernstein and Lorraine Hansberry—but I had no idea he'd ever been near Truman Capote. And when I had the negatives printed, my jaw hit the floor. These were the coolest pictures of Capote I'd ever seen, framed like shots from a Hitchcock movie. The still young, steely-eyed scribe looks like he's creating his own mythology right in front of the camera.

How had I never seen these before? How were they not hanging in major museums, let alone languishing unseen in a dust-covered wooden box?

Fortunately, Mr. Capote has a very healthy Internet presence. And with some help from my father's writings and my mother's recollections, I was able to piece together the story of these photographs, and exactly how my father's career had intersected with and in some ways been birthed by Capote's.

By the late 1950s, my father's chosen career, commercial illustration, was dying fast; magazines and publishing houses were turning to photographs instead of those antiquated, *Mad Men*-era line drawings. He decided to make the switch, and signed up for Brodovitch's photography course at The New School. Brodovitch, the longtime art director of *Harper's Bazaar*, is considered one of the fathers of modern magazine design; he's credited with inventing the two-page spread—which, let's face it, is a bit like inventing the sandwich. He was a very big deal. He was also a very tough teacher, and his course was a visual-arts version of the movie *Whiplash*. If he didn't like your work, he'd rip you to pieces.

One night, my father was developing film for his very first class assignment, when he realized he'd overexposed every single frame. Class was the next day. In other words, he was toast—and so was his new career. In a desperate panic, he started layering the negatives together, to create moody, impressionistic montages. His life must have been flashing before his eyes, and at the wrong exposure.

Brodovitch loved the montages. He spent the entire class gushing over them. And

on the final night of the course, he offered my father his first-ever professional assignment: to illustrate *Breakfast at Tiffany's* for its debut in *Bazaar*, with a series of his now-signature montages. Not bad for a first-timer. He worked around the clock for almost two months to complete the job.

Meanwhile, the Hearst Corporation, which published *Harper's Bazaar*, was having second thoughts about *Tiffany's*. This was, after all, a story about a woman who slept with men for money. Not to mention, Tiffany's was a major advertiser in Hearst magazines. The publisher wanted changes to the novella. Alice Morris, the fiction editor of *Bazaar*, has said that while Capote initially refused, he relented "partly because I showed him the layouts . . . six pages with beautiful, atmospheric photographs." (I've since found all the *Tiffany's* work, and Capote was right. Not bad for a first-timer indeed.)

Capote made all the changes, but Hearst told *Bazaar* not to run the novella anyway. Capote resold it to *Esquire*, without any of the photographs, where it flew off newsstands and rightfully made him a star. But everyone had loved my father's work, and in his words, "my new career was launched."

A couple of months later, as Mr. Plimpton explains, *Holiday* magazine asked Capote to write the evocative essay that opens this book. I can only guess that Capote himself recommended my father to illustrate it, but there's no way to know. Sometime in March 1958 (at least I think "A3/58" means March), they spent a full day together. First, my father took portraits of Capote and some shots of the house on Willow Street that he called home. Then Capote led him around Brooklyn Heights and what is now Dumbo, showing him favorite haunts and local characters. My father spent another handful of days photographing the neighborhood on his own. Their work ran in the February 1959 issue of *Holiday*.

I managed to find a copy on eBay and couldn't wait to see which Capote pictures the magazine had used. To my amazement, *Holiday* used only four of the neighborhood shots—and not a single picture of Capote himself.

I'm embarrassed to admit that, even after seeing them in print, I wasn't especially interested in the neighborhood shots; I didn't even take those negatives out of their thickly stuffed envelopes. My mandate, after all, was to gather pictures of "famous people." I was starting to get some interest in them, and the Capote portraits were many people's favorites. When I learned that the original Capote essay had been turned into a small book in 2002—without any of my father's work—I sent an e-mail to the publisher, The Little Bookroom, through the "contact us" link on its website. I suggested that my unseen shots of the very famous author might be useful for a second edition. And did I mention that he was famous? No reply.

Maybe the single luckiest thing I did in this whole process was to send that same e-mail a second time, several months later, using the same nameless link. Because this time, I got a quick reply (the first e-mail apparently never reached its destination) and started corresponding with the publisher and editor of this book, the wonderful Angela Hederman. She quickly decided to do a second edition, incorporating the Capote portraits. She also asked to see the neighborhood shots, which I still hadn't looked at myself. I scanned them, about eight hundred of them, on a home office scanner and barely even looked at them. A day or two later, she replied: "I think we have a photo book!"

Only then, in my dumbfounded amazement, did I take a good look at the images that became this book and realize: Hey, these are even better than pictures of famous people.

It goes without saying that they have historic value. The connection to Capote and the Brooklyn he describes would probably be enough to justify their resurrection. But to me, there's also a real tenderness to their point of view, a real empathy and connection. This is mid-century street life captured by a guy who, himself, grew up on the streets of Brooklyn.

A lot about the shoot is still a mystery. There are less than twenty shots of Capote in total, far fewer than a traditional portrait shoot. Even while leading my dad around Brooklyn, he pops up just a few more times. Maybe *Holiday* never intended to run a picture

of Capote, who wouldn't reach the literary stratosphere till later that year, when *Tiffany's* finally appeared. Maybe he didn't want photos of himself used. The shoot included a handful of portraits of other Heights luminaries, including, astonishingly, W. E. B. Du Bois, who lived on Grace Court, a few blocks away from Capote. Did Capote bring my father there? Were he and W. E. B. drinking buddies? Was he mentioned in some early draft of the Capote essay? Impossible to know.

Friends have asked me if it's an emotional experience to look at these photographs, taken before my parents had even met. It's better than that. Because nothing is distilled, in the way that emotional experiences tend to be. As I look at frame after frame, I'm right there on the street with my dad, moving from block to block, lingering on what he likes, moving on from what he doesn't. It's a feeling of presence, not absence.

I learned some personal things too. The man being shaved in the barbershop was a friend of my father's, Gabe Katz. According to my mother, I would've been named Gabriel myself, but my father didn't want Gabe—a close friend but apparently not close enough— to think I was named after him. There are also some shots (not included in the book) of a girlfriend, carrying a tripod, helping my dad as he hustled around the Heights. I met her many years later, at an uncle's wedding anniversary, at which she told me that my father was quite the hipster in the '50s, introducing her to such foodie novelties as Chinese food and Pepperidge Farm bread. I find myself looking at the photos of her, hoping it won't work out between them.

Perhaps the biggest thing I learned is that while my father shied away from straight, documentary-style photography, like the work in this book, he was great at it. He once wrote that he "never made peace with photography in its simplest expression. Because I started at a time when the great portraits by Penn, Avedon, and Arnold Newman were being made, I did not wish to imitate that work." He wanted to be an original. But I know from my mother that he was also insecure, worried that he couldn't compete with those

big names on their own turf. That led him to focus on his accidental-signature montages, on "self-portraits" in which his subjects controlled the exposure—on things that were, in his words, "anti-photographic." I love that work, too. It gave him his great career. But in my view, he had no reason to be insecure.

I should mention that this book came together so quickly, we almost weren't able to include Capote's essay. His longtime attorney and close friend, Alan Schwartz, a renowned entertainment lawyer, controls Capote's literary rights. We were told the pace would be glacial. As our deadline neared and no one had even heard from him, Schwartz became a mythic figure to me, a literary Wizard of Oz. Who was this guy? Once again, I turned to Google, only to learn from the very first click that his son was an old friend of mine, the novelist John Burnham Schwartz. (I'd even been to Alan's house; I should really be better with names.) Alan turned out to be as delightful and approachable as his son. They both saw the merits of the project, and we had the rights within days. I'm grateful to both of them. As I'm grateful to Angela for her keen eye, her sense of narrative, and her incredible sensitivity to my father's work. And to Brian for wanting to resurrect my father's work in the first place, and making me realize I wanted that, too.

What's most remarkable is that the story you've just read, and the book you hold in your hand, represents just one week of work in a wide-ranging, twenty-five-year career. Who knows what stories are lurking in the rest of those dust-covered wooden boxes? Maybe some of them will end up on the Internet someday.

—*Los Angeles*
May, 2015

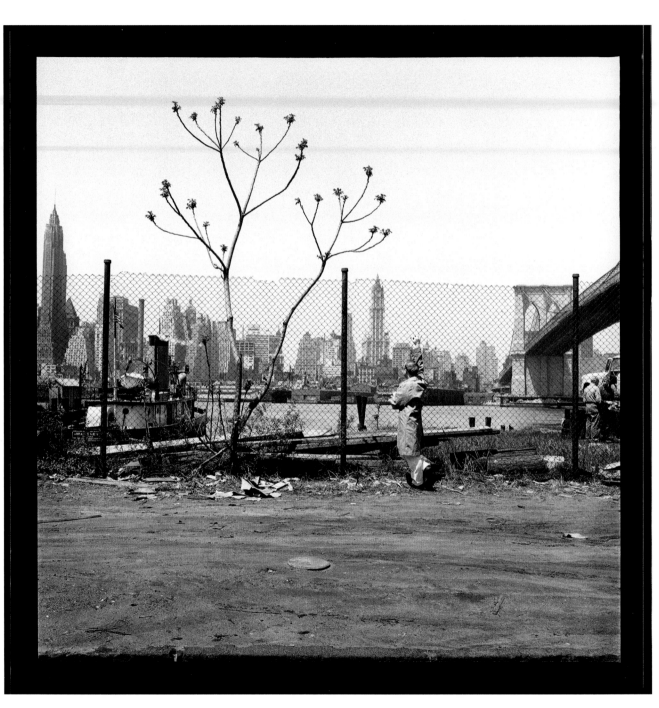

Design Katy Homans
Cover: Truman Capote on the back porch of 70 Willow Street, 1958
Page 98, Photo of David Attie, photographer unknown.
All attempts have been made to identify the photographer. If the information becomes available,
the publisher will credit the photographer in all future editions.

With gratitude to Evan Walsh, Chris McElrath, and Rob Diaz at Contact Photo LA for their brilliant scanning and printing.

To purchase prints and for further inquiries about the David Attie archive, please contact DavidAttiePhotos@gmail.com.

ISBN 978-1-936941-11-7
Library of Congress Cataloging-in-Publication Data
Capote, Truman, 1924-1984.
[Brooklyn Heights]
Brooklyn : a personal memoir : with the lost photographs of David Attie / by Truman Capote ;
photographs by David Attie ; introduction by George Plimpton ; afterword by Eli Attie.
pages cm
ISBN 978-1-936941-11-7 (hardback : alkaline paper)
1. Capote, Truman, 1924-1984--Homes and haunts--New York (State)--New York. 2. Brooklyn Heights (New York,
N.Y.)--Biography. 3. Authors, American--20th century--Biography. 4. Brooklyn Heights (New York, N.Y.)--Pictorial works.
5. Brooklyn Heights (New York, N.Y.)--Intellectual life--20th century. 6. Brooklyn Heights (New York, N.Y.)--Social life
and customs--20th century. 7. New York (N.Y.)--Biography. 8. New York (N.Y.)--Pictorial works. 9. New York (N.Y.)--
Intellectual life--20th century. 10. New York (N.Y.)--Social life and customs--20th century. I. Attie, David. II. Title.
PS3505.A59Z469 2015
813'.54--dc23
[B]
2015017904

THE LITTLE BOOKROOM
435 Hudson Street, Suite 300
New York NY 10014
editorial@littlebookroom.com
www.littlebookroom.com